learning to draw

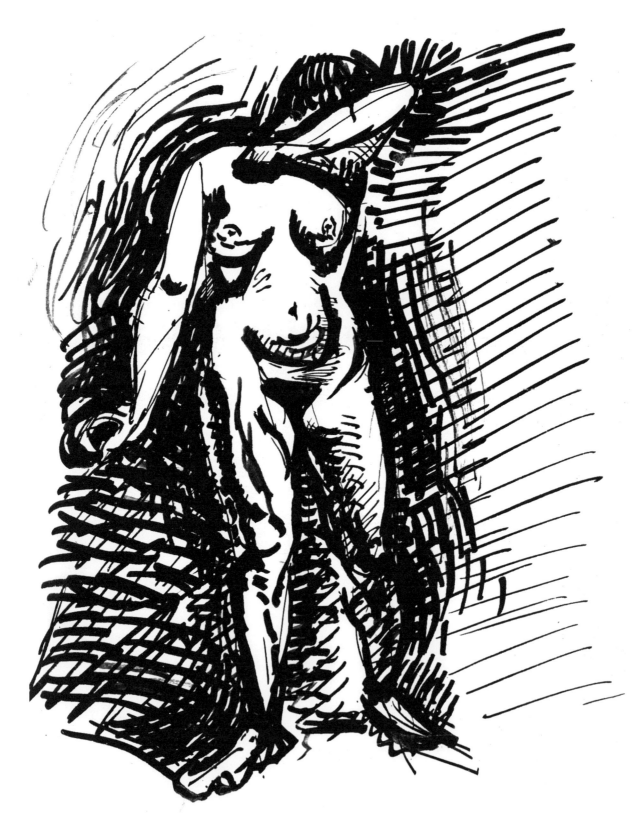

HENRI MATISSE Figure Study Pen and Ink 10-3/8" x 8" The Museum of Modern Art Gift, Edward Steichen

learning to draw

A Creative Approach To Expressive Drawing

by Robert Kaupelis

Associate Professor of Art Education, New York University

Watson-Guptill Publications *New York*

ISBN 0-8230-2675-2
Library of Congress Catalog Card Number: 66-13002
First Printing, 1966
Second Printing, 1969
Third Printing, 1970
Fourth Printing, 1972
Fifth Printing, 1974

Edited by Susan E. Meyer
Designed by James Craig
Photocomposition in eleven point Baskerville by Noera-Rayns Studio, Inc.
Bound by Chas. H. Bohn Company, Inc.

To Pecky, Khym, Khy and the hundreds of students who were my teachers....

acknowledgments

I am indebted to the hundreds of students whose enthusiasm and response to my teaching methods have given this book its reason for being. All I can say is thank you. I regret that I was unable to include the hundreds of additional drawings made available to me by students, and I give special thanks to the students whose work is included and whose names appear throughout the text. The Metropolitan Museum of Art, The Museum of Modern Art, The Chicago Art Institute, The Philadelphia Museum of Art, and the Sterling and Francine Clark Art Institute were all most generous in granting permission to reproduce drawings from their collections. Stephen H. Goldberg, Charles Uht, and John F. Waggaman deserve the photographic credits. Donald Holden and Susan Meyer, my editors at Watson-Guptill, deserve gold stars for their patience and understanding. I am especially grateful to Howard Conant who not only wrote the preface, but encouraged me in the early phases of the writing, read the text, and has made it possible for me to teach drawing over the years at New York University. To list the contributions of my wife, Pecky, would necessitate the addition of another chapter.

contents

preface

The publication of Robert Kaupelis' important new text, *Learning to Draw,* is a major event in the art education profession. Not since Kimon Nicolaides' *The Natural Way to Draw* have we been offered a drawing text which not only updates, but extends that master-teacher's unique and highly effective method of teaching.

Learning to Draw is indeed a *cause célèbre* for art education, not only because it meets the urgent professional need, but also because it combines artistic, aesthetic, and instructional considerations in a way which is significantly different from any other text. Yet it is different in a way which incorporates many of Nicolaides' best teaching methods. Another feature of great importance in this new book is Kaupelis' inclusion of choice examples and highly perceptive analyses of drawings by artists of the past and present. This feature incorporates some of the best aspects of Bryan Holme's *Master Drawings* and Robert Beverly Hale's *Drawing Lessons from the Great Masters.* To these illustrations, Kaupelis has added many splendidly reproduced works by college art students.

Learning to Draw is bound to be enthusiastically received and widely used; but even more important, it will help point the way for an art teaching profession which, inadvertently or otherwise, has neglected the development of its own, as well as its students' aesthetic awareness and art historical knowledge, and has continued to use outmoded methods in the teaching of drawing and other means of creative expression.

Both in his text, and in the illustrative material which accompanies it, Kaupelis reveals a level of style and degree of aesthetic judgment which is entirely consistent with his own truly original method of teaching. The text is as orderly, but as flexible and adaptable to change, as is his own teaching. He strongly encourages both instructors and students to use his suggestions in ways they feel most appropriate. He would be disappointed if the reader were to follow his suggestions in a step-by-step fashion.

Among other significant, unusual, and commendable features of *Learning to Draw* is Kaupelis' careful attention to captions for the works he has chosen to reproduce, captions in which he provides specific, pertinent, thorough, and profoundly useful analyses of the underlying aesthetic qualities of the drawings. He speaks directly and unequivocally, yet sensitively, about the artistic qualities of line, texture, rhythm, balance, and composition, from the reliable and insightful viewpoint of a successful, practicing artist and teacher.

If enough teachers and individual readers would permit it to do so, *Learning to Draw* could have a revolutionary effect upon both artistic expression and aesthetic understanding. It is my sincere hope that this long-awaited approach to the solution of two of art education's most important and persistent problems will be given the fullest possible application.

<div style="text-align:right">

Howard Conant
Professor and Chairman, Department of Art Education
Head, Division of Creative Arts, New York University

</div>

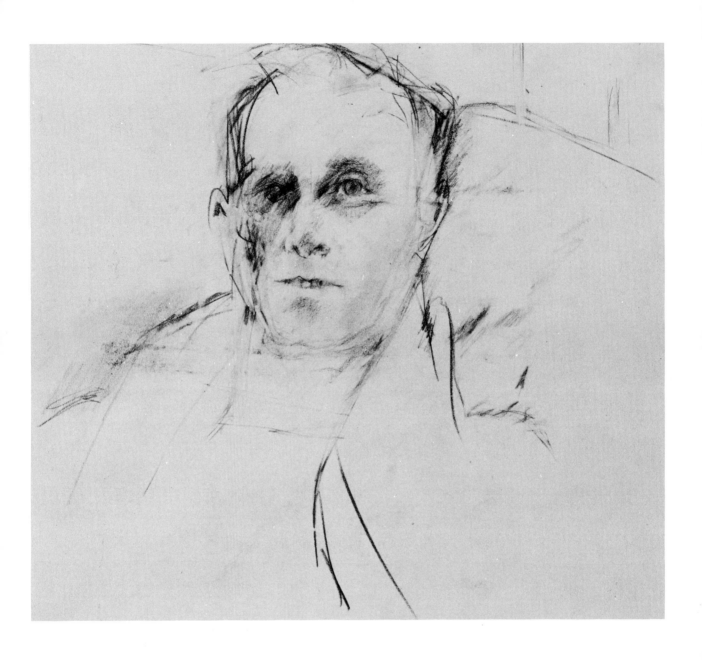

LARRY RIVERS
Portrait of Edwin Denby
Pencil
16-3/8" x 19-3/4"
The Museum of Modern Art, New York.

"I am a political man. I am affected by what other men do & say & think & how they respond to what I do & say & think. Putting aside the surface manipulation of subject & style, what I have painted is my relationship to other men & that relationship points out our differences & our similarities. I see in my work every art from Rembrandt to the man who presents a No Smoking sign to us as art." — Larry Rivers

introduction

Essentially, *Learning to Draw* contains the exercises and methods I have used over the years in teaching *Fundamentals of Drawing* at New York University. My approach in this book grows out of the classroom procedures, but I have modified these procedures and explained them in a manner which should make them useful to the student working by himself as well as to the student working in a class with a qualified teacher.

No book, including this one, can replace the motivation and knowledge you can receive from a teacher passionately involved with art. I hope, however, that the present volume will provide some direction to the student working alone and will supplement the drawing experiences of those students working with a teacher.

THE METHOD If you glance quickly through the pages of this book, you will see immediately that I have a definite viewpoint about teaching drawing, but one which is extremely flexible and open-ended. I certainly do not expect students or other teachers to accept my views *in toto*. You can accept, reject, or reinterpret any number of the possibilities and suggestions contained in the text and reproductions (in terms of your individual needs and/or specific classroom situation) yet still benefit from the approach to drawing described in this book. There is nothing sacred about the order of problems I have suggested and I frequently present them to my classes in a variety of other sequences.

THE ILLUSTRATIONS The careful and extended study of old and modern master drawings is extremely important to your development as an artist and you should devote a good portion of your time to the examples illustrated in this book and in the books listed in the bibliography. The master drawings—reproduced full-page—are in no way intended to present a history of drawing. I have selected them to show the range of expressive intentions possible, because they have profound aesthetic

qualities, or because they illustrate the problems I present in the text.

Study the master drawings especially to see the way in which all the elements are organized to create a unified drawing — a drawing in which all parts appear coherent, contributing to an over-all structure. For this reason, the master drawings are distributed throughout the text, even when they do not relate directly to the topic or problem under discussion.

The bibliography, though limited, offers some suggestions about where you can locate other reproductions of master drawings. Of course you should never miss an opportunity to study the masters in the original, at museums and galleries.

The pictures of student work — reproduced on a smaller scale — are intended to show you how other students have handled a number of the exercises, although not every exercise is illustrated. These illustrations are not the only way to handle the problems, and rather than inhibit you, they should point the direction to hundreds of other creative solutions. These examples come primarily from freshman classes in college, but I have effectively used many of the same problems in working with secondary and even elementary school children.

THE MODEL The majority of problems presented in this text use the human figure as the motif. This reflects my own bias, since I do not believe there is any other subject which is as dynamic and visually compelling as the human figure.

Though drawing from a nude model is definitely an advantage, it is not absolutely necessary. Your family, friends, or classmates might volunteer to pose in leotards or bathing suits. Members of your family are probably relatively quiet while they watch television and you can find hundreds of models (in all sizes and shapes) in public places such as a park, bus terminal, or swimming pool. A large mirror will enable you to pose for yourself when you do many of the problems. Moreover, if it is absolutely impossible to use a posing model, most of the problems can be executed using still life materials.

THE FUNDAMENTALS As a student beginning to draw, you are probably anxious to acquire what you consider to be the fundamentals of drawing. Exactly what the fundamentals of drawing are poses a difficult and even controversial question.

In western civilization (which eliminates the cultural traditions of about three-quarters of the earth's population), we tend to consider the fundamentals those values, techniques, and skills which were developed during the Renaissance. Though there is much validity in this concept, a good deal of what has happened in the history of art *since* the Renaissance — particularly during the past hundred years — has challenged these values, pointing the way toward new and perhaps more basic fundamentals.

Rather than regarding the fundamentals of drawing in terms of such values as photographic realism, accurate perspective, smooth finish and technique, many of us now feel that the following factors — and related values — constitute the fundamentals and that all else will follow naturally.

Concepts By this I mean the richness of your aesthetic awareness; your willingness to accept and respond to a broad range of profound aesthetic expres-

sion and form in any form of artistic creation.

Confidence You must have confidence in yourself and be committed to your drawing—hopefully to every drawing you do. You must develop the confidence necessary to attack most any subject, turning it into a personal aesthetic statement.

Sensitivity This refers to your ability to respond, to feel the obvious, as well as the more subtle relationships between such things as form, content, subject matter, materials, and techniques.

Materials If you are ever to make your expressive intentions tangible, it is essential to have an understanding and sensitivity to materials, their potentials, and their limitations.

Art History André Malraux has noted that art is born of art. Familiarity with art history is an absolute necessity to understand what man has accomplished artistically in the past as well as the reasons for our present attitudes, knowledge, and values as related to art. This of course includes the art and the social and economic conditions of the present time as well as the past.

Flexibility This refers to your ability to adapt all of your skills and knowledge to any new or different artistic problems or judgments you might face. A flexible artist should be able to work loose, tight, big, small, from the parts, from the whole, fast, slow, carefully, carelessly; he should be able to work in line or without line, with or without erasers; he should be able to build in order to destroy and destroy in order to build.

Understanding Understanding develops through all of the senses, though for the artist sight is probably the most important. You must understand forms, events, experience and intentions (your own and others) on both an intellectual and an intuitive level. At times, we understand things which are inexplicable in terms of bodily sensations and feelings. Understanding, as it functions on many different levels, might be better understood if I cite an example: the non-artist who sails boats can probably draw a more complete, a "better," more detailed picture of a sailing sloop than an artist. Although the result may be more complete as a picture of a sloop. I doubt that it would be as complete in terms of an aesthetic entity. The artist's major asset is that his understanding is primarily aesthetic.

Originality If your work is to be your own—in its form and expressive content—it must be unique and personal. It's possible to develop a facility for drawing stereotyped and hackneyed compositions which are slick, impersonal, and trite; but producing drawings which possess aesthetic significance demands responses and forms that are uncommon, unusual, and individual; that is, original.

It is certainly my hope that the following exercises and suggestions will help you master some, if not all of these fundamentals. Finally, since you cannot learn to draw simply by reading about it, and since no single book or classroom approach can possibly "teach" you to draw, I suggest that you wed yourself so thoroughly to your sketchbook that it almost becomes a physical extension of yourself.

And now what you must do is draw and draw and draw and look at drawings and draw and draw and draw and look at drawings and draw...

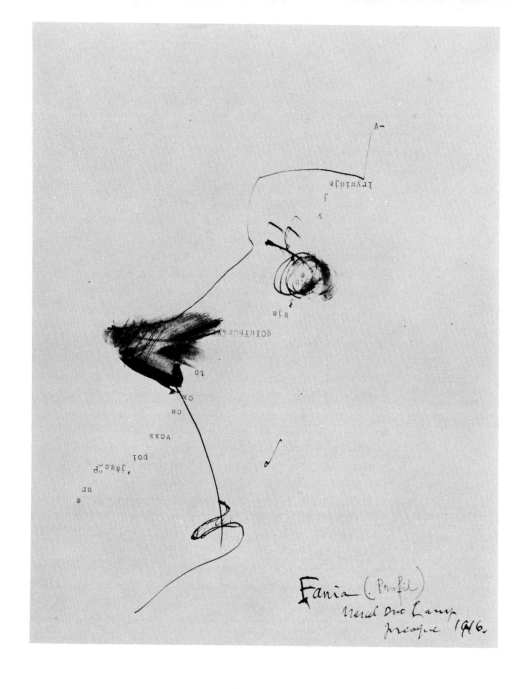

MARCEL DUCHAMP
Fania (Profile)
Louise and Walter Arensberg Collection
Philadelphia Museum of Art
Photograph by A. J. Wyatt

Disillusioned with the society that produced the horrors of World War One, many artists set out to destroy all the values of that society including its aesthetic values. These artists adopted the French word, *dada,* as their rallying cry, a word which literally means hobbyhorse. Their art work was characterized by spontaneous acts and gestures, by automatic responses, and by the transformation of everyday forms, objects, and debris. In addition to pen and ink, Duchamp uses some nonsense words from a typewriter to create a portrait. Despite their anti-aesthetic attitude, the dada painters made a contribution to contemporary art by extending the range of our aesthetic means and our aesthetic responses. They were artists despite themselves.

1 drawing materials

A drawing material can be made from anything you can dip into paint, ink, or dye. A drawing material is anything which leaves a mark when you drag it across paper, wood, cardboard, clay, or other surfaces.

When we think of drawing, we generally think of pencils, pens, and brushes; however, it's possible to use many other materials, each of which can be exploited for its own unique qualities. Marcel Duchamp, in the accompanying portrait, used not only his fingers as drawing instruments, but also a typewriter!

Twigs of various sizes will produce interesting lines. You can dip tennis balls into paint or ink to achieve a big, bold line or to smear a large area of tone into a composition. Rope and string will produce a wiggly, nervous effect, because the ends cannot be controlled in the same tight way as those of a pencil or pen point. Crumpled tinfoil, dipped into ink, can be used like a rubber stamp to lay in a tonal area and create an unusual texture simultaneously. Likewise, corn cobs, sponges, or other highly textured materials can give interesting tonal effects.

With pipe cleaners, you can make lines with the tip or you can drag the side across the page to get a rich, striated effect. You can achieve a similar effect with a toothbrush or a comb. Razor blades can be dragged across a wet area of ink or paint and, depending on the rhythm of the movements, they can be used to create endless variety of lines, tones, and textures. Razor blades can also be used to scratch into tonal areas after they are dry. Saliva might be the handiest source of moisture when you want to smudge an ink or pencil line in your sketchbook. And to these materials, I could also add paper straws, clothespins, tongue depressors, feathers, vegetables, sand, and orangesticks.

Although these suggestions may seem a little strange, I've seen all the materials used at one time or another. Actually, I feel that materials in and of themselves are very unimportant. Nevertheless, your attitude toward the materials is important, having a profound effect on your approach to drawing.

ATTITUDE TOWARD YOUR TOOLS

All too often, materials become an inhibiting factor for the beginning student. Instead of "bending with the material," instead of seizing upon the terrific potential inherent in the materials, the beginner too often allows the materials to create a wall between himself and the paper.

Oh, that paper! That beautiful, spotless, white sheet of paper! It's so unfair to destroy it, to make a mark on it! To smudge it! I've heard of one drawing teacher who makes his beginning students crumple and step on their drawing paper before they start to draw. What's the point? Being free and unafraid is the point; his method helps to smash the inhibiting barrier of the beginner's precious attitude toward the tools. After all, they are only tools, an extension of your hand, a means of making tangible what you are, think, feel, and see!

For many years, I had my students do most of their work on newsprint, giving them an occasional exercise to do on a better grade of drawing paper. Invariably, when they switched from the newsprint, their drawings would become tight, stiff, cramped, and precious. Recently, I've insisted that they do all their work on an inexpensive bond paper, not quite as inferior as newsprint. This request has produced a remarkable change in their attitude. They continue to understand that each drawing is merely an exercise, an experience, and perhaps a discovery. The transition from working on a cheap, inferior paper to one with some quality has been made less of a gap and their attitude is much freer.

RESPECT AND CRAFTSMANSHIP

By saying these things, I don't want to imply that I lack respect for materials, or that I have a sloppy attitude toward craftsmanship. On the contrary, I'm encouraging a drive for *greater* respect and craftsmanship which springs from a deep knowledge and sympathy for the possibilities and limitations inherent in all materials, whether they are scraps, free, cheap, or extremely expensive.

USE THE WHOLE ORCHESTRA

So, I ask you not to worry too much about materials—at least in the beginning. Below is a list of materials I suggest to my students and which, much to their chagrin, I require them to bring to each class. You never know when you'll want to hit another note on the violin and no string should be missing when you reach for it.

PAPER

The variety of papers available is practically endless. It's an important factor, since the type of paper you use affects the character of your drawing just as much as the tool you draw with. The character of a pen line is entirely different on a hard, smooth paper from that on a soft, rough surface. Experiment with as wide a range of papers as you can obtain.

I generally recommend an 18 x 24 bond paper pad which has a fairly smooth surface and is satisfactory for pencil, Conté, pen, and brush drawings. Charcoal paper in approximately 18 x 24 sheets or pads has a rough or grained surface and is excellent for charcoal, pastel, and chalk drawings. You can buy charcoal paper in a variety of colors in addition to white. Furthermore, you should have a medium weight, all-purpose drawing paper with a medium surface, paper which can be used with almost any material suggested. I find 19 x 24 sheets of Strathmore Alexis quite satisfactory for this purpose.

It's more economical to buy paper in bulk rather than in pad form or by the single sheet. Some papers are offered in packages of one hundred sheets, but more often paper is sold by the ream (500 sheets). Paper is graded by its weight per ream. A 60 lb. drawing paper means that a ream should weigh 60 lbs., a fairly lightweight paper. A sheet of 140 lb. paper is almost like a lightweight cardboard.

SKETCHBOOK Sketchbooks are available in all sizes with either spiral or sewn bindings. I like my students to use a 9 x 12 sketchbook or larger since the smaller sketchbooks seem restricting. You should have your sketchbook with you at all times; it should become a part of you; in fact, you should feel "undressed" without it.

PENS AND INK There are a number of good drawing inks available. Perhaps the most widely used is black India ink, which is waterproof and therefore excellent for wash drawings in which you build up layer on layer of tone. Although standard black and sepia (a brown tone) are the most popular, drawing inks come in a wide range of colors.

Pen points come in a vast array of widths, shapes, and flexibilities. They demand experimentation though I usually recommend a crowquill pen which is delicate and flexible. I also recommend Gillott #290 and Speedball lettering pens numbered A-5, A-3, A-1, B-6, B-3, C-6, C-3, C-1.

There are at least several dozen varieties of felt or nylon tip marking pens on the market, all of which seem to produce a slightly different line. They now come with both waterproof and water soluble ink. I personally prefer the water soluble variety since you can produce a variety of tones by smudging a line with a little water.

Bamboo pens, which are literally what the name implies, produce a very beautiful line. They are inexpensive, so I suggest you purchase several different sizes.

There are several artist's fountain pens on the market which use either regular writing ink or India ink. Since these pens have a flexible point which allows for a wide variation in line quality, I recommend them over the popular Rapidograph, a fountain pen with a variety of different points. If you want a wide line with the Rapidograph, you have to change points.

PENCILS AND GRAPHITE Drawing pencils are manufactured in eighteen different degrees, ranging from 9H (the hardest point which produces the lightest line) to 7B (the softest point which produces the darkest tones). You might start by purchasing a 6B, 4B, 2B, HB, 2H, 4H, and 6H.

Chisel-pointed sketching pencils also produce an interesting line and I recommend a 2B, 4B, and a 6B.

Graphite also comes in solid, rectangular sticks measuring about ½ x ¼ x 3". You can use the edge of graphite sticks to produce wide tones and the tip to produce lines.

CHALK AND CHARCOAL Charcoal is produced in three forms: a natural vine form; a compressed chalk-like form; and in the form of a wooden pencil. All charcoals come in soft, medium, and hard. Personally, I don't find the vine variety as useful as the other two.

Layout chalk is useful for developing a variety of middle tones in your drawings because the chalks come in both warm and cool grays. They are commonly sold in a box of eight shades.

Colored chalk and pastel are sold in sets ranging from a twelve-color assortment to one hundred fifty-color assortments. They may also be purchased individually in large art supply stores. Purchase whatever you can afford.

CRAYONS

School-type wax crayons are useful, but I believe they have been largely superseded by oil base crayons, such as Cray-Pas or Sketcho, which can be mixed, smudged, and blended to achieve a variety of new colors and textures. The larger the set you purchase, the greater the range of possible expression.

Conté crayons produce a line and tonal quality lying halfway between charcoal and crayons. Conté crayons are produced in hard, medium, and soft, and in black, sanguine, and white.

Lithographic crayons are a grease crayon used mainly for producing graphic prints on stone or zinc plates. They are also fine for drawing on paper and I suggest that you experiment with #0, #2, and #3.

ERASERS

There are three basic types of erasers: the gum eraser, very soft and pliable, will not damage the surface of the paper; the kneaded eraser, also soft and pliable, can be molded like clay into any point or shape and is especially useful for erasing chalk, pastel, or charcoal; the soft pink pencil eraser erases regular pencil lines.

BRUSHES

It's extremely difficult to recommend specific brushes since any wide assortment of soft camel hair brushes and stiff bristle brushes is really adequate. Sable brushes are preferable to camel hair brushes but extremely expensive. Most of my students use medium priced camel hair brushes with satisfactory results. In your initial equipment, I suggest you include one inch and two inch varnish or enamel brushes of the dime store variety; #3 and #7 flat, white bristle brushes; #3, 7, 9, and 12 red sable or camel hair brushes; and a #11 bamboo brush which is the type that the Japanese use to produce their beautiful calligraphy.

MISCELLANEOUS

Here are some additional items of equipment that I'm sure will be valuable to you.

Drawing paper which comes in rolls of ten yards by 42 inches is marvelous for loosening up and doing really large drawings. Black and white tempera or showcard color is useful. Newsprint paper, which comes in 18 x 24 pads or packages, is the most inexpensive paper available and you might want to use it for your rapid gesture drawings.

A drawing board large enough to accommodate your 18 x 24 paper is a convenient item. Since the regular, manufactured drawing board is fairly expensive, I recommend a piece of Masonite or plywood (from the lumber yard) as a sufficient substitute.

Masking tape always comes in handy.

Plastic fixative spray, which comes in 12 oz. spray cans, is convenient for fixing (making permanent) chalk, charcoal, and pastel drawings.

Razor blades are necessary for sharpening your pencils, which are "eaten up" in regular pencil sharpeners.

Used as a container for water, a coffee can is perfect.

A large mixing tray or palette is a vital piece of equipment for certain media. Cookie tins serve this purpose very well.

The best means of storing all the above equipment is in a good-sized fishing tackle box.

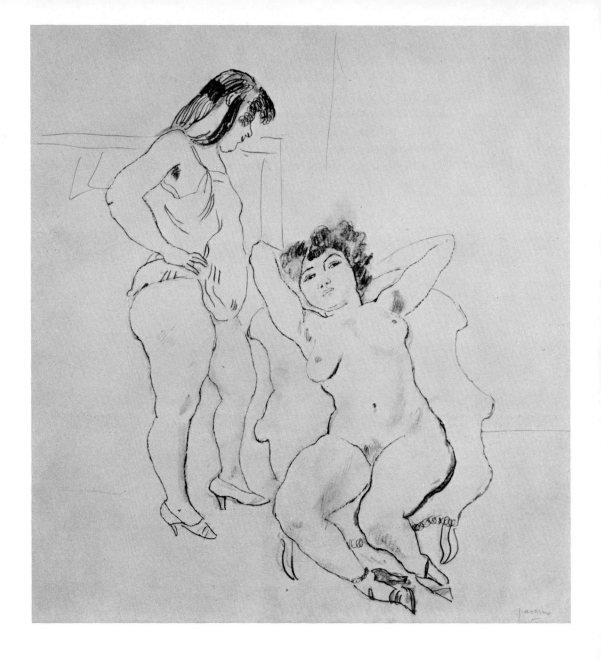

JULES PASCIN
Two Nudes
Pencil
19-1/2" x 18"
Philadelphia Museum of Art.

These women are hardly what you'd call "ideal beauties!" Pascin's line, like that of George Grosz, is as sharp as a dull razor and can cut with a vengeance. Are these "accurate" drawings? They are deadly accurate...in terms of what Pascin wanted to communicate. Why, after developing the three dimensional quality of the figures through contour lines, did he produce a flat, outline drawing of the chair? Is it *really* inconsistent? What prevents the figure from floating in ambiguous space? Was Pascin incapable of drawing a smooth line? Or a pretty girl? Could the floor line really change position so much from the left to the right-hand side of the drawing? Was he concerned with the organization of the total page? What does the subtle line in the center background do? What *is* the difference between these nudes and the nudes of Eakins?

2 contour drawing

Though the type of drawing you start with is certainly a matter of personal preference — your preference or your instructor's — it's been my experience that contour drawing often proves the most rewarding. Despite the fact that contour drawing requires a great deal of concentration and application, even the most untutored beginner can achieve some degree of success and thereby develop a modicum of confidence in his ability to draw.

Inevitably, at the end of this first session of contour drawing, I've been able to state quite honestly: "There, now you've proven that you can delineate a given form on paper. Your drawing is convincing, and even expressive, so don't let this worry you any longer, but go on to develop your abilities and refine your sensibilities. You did these drawings *blind*. Imagine what you'll be able to do later when you're permitted to look while you draw!"

WHAT IS A CONTOUR DRAWING? Contour drawings are the result of learning to "see" through the sense of "touch." Most drawings begin with a generalized outline of the total form and gradually refine down to minor forms and details. But contour drawings are line drawings which are developed form by form, or detail by detail, to arrive at the completed form.

Perhaps the simplest way to understand a contour drawing is to begin by making a tracing of your thumb. In theory, this should be the most accurate linear definition of your thumb; yet there seems to be a great deal missing. In fact, this outline drawing of your thumb might be difficult for another person to understand if he didn't see you draw it. Perhaps it's not a thumb at all, but just a wiggly line.

This outline drawing exists as a simple silhouette, a *flat* shape, a shape which is one with the surface of the paper. Flat shapes like this, which exist on the surface of the paper, are often referred to as *pattern*. That is, such shapes describe *space* as it moves horizontally, vertically, or diagonally across the page.

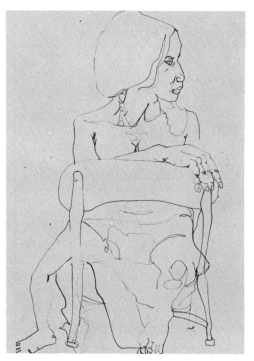

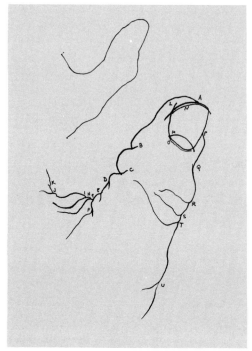

Pen and ink were used in this contour drawing from a live model. The student was asked to draw without looking at the paper. Drawing by Deidre Channing. Photo, Waggaman.

I did this drawing to illustrate the difference between an outline drawing—in fact, a tracing—of a thumb and a contour drawing. Contour drawings indicate all three dimensions of a form; an outline indicates only two.

The outline of the thumb describes only two dimensions. This is why it's difficult to "read" the form as a thumb. We know that a thumb has three dimensions; some indication of the third dimension is necessary to help us "read" the form more clearly. A *contour drawing* of a thumb—as opposed to an outline drawing—describes or alludes to all three dimensions: length, width, and depth. Contour drawing creates the illusion of three dimensional form on a flat surface.

A FIRST EXERCISE IN CONTOUR DRAWING
Consider how the so-called blind contour drawing illustrated on this page came into existence. This will help you to understand the approach to this particular exercise. In fact, try it yourself. The drawing of the thumb is developed by drawing one contour or detail at a time. You must keep your eyes on the form of the thumb while the pencil delineates the form on paper.

The drawing on this page was begun at point A. Of course you look at the drawing paper to set your pen or pencil in position; but then you must concentrate on the form, allowing your eyes to move slowly along the form while the pencil moves along the paper. You must imagine that the pencil is actually touching the form of the thumb. When the form or contour appears to end—or when it meets another contour—you stop "feeling the form with your pencil" and look at the page. You then set the pencil down in the proper location to begin the next contour line: point B on this page.

You now progress to each succeeding contour, drawing blind while you "feel" the form with the end of your drawing instrument. You'll be most successful if you're able to lose yourself completely in the feeling that your drawing implement is touching every form. This kind of identification with form—called empathy—isn't easy to achieve. It demands complete and utter concentration on the form you're delineating. In fact, if you don't have a headache after several hours of contour drawing, you can be sure that you haven't been applying yourself to the problem.

DON'T WORRY ABOUT "GOOD DRAWING"

It's important to draw as though you *mean* it. Use a definite, confident line. It's impossible to "feel" the form with a sketchy line. Drawing with a sketchy line, in this case, is like tapping your finger along the form when you really need to caress the form with your pencil. Don't worry about distortion. If you follow the procedure I've outlined, a distorted form *must* result unless you're cheating (looking at the page while you're drawing). In fact, lines that *should* meet will often not do so. But you needn't be worried about this problem. Nor should you erase what seems like a "mistake." It's nearly impossible to achieve "correct" proportions when drawing line by line as you do in contour drawing. Good drawings, in the conventional sense, are not the objective at this point. We're simply concerned with an exercise in seeing. Though good drawings are *not* the objective, I might add that students often produce some of their finest work during this early period. They achieve handsome results precisely because they're convinced that it's only an exercise. Thus, they feel less self-conscious than when they consciously set out to make a "good" drawing.

MAKING A "BLIND CONTOUR"

At this point it's advisable that you spend several hours drawing. But now, instead of starting with a simple object like your thumb, you should try one of the most difficult objects to draw: the human hand. The most important characteristic of this particular form is that it's composed of a number of joints or knuckles. It will help if you pose your hand while drawing. Bend and twist your hand until you achieve an interesting arrangement of forms; then begin to draw.

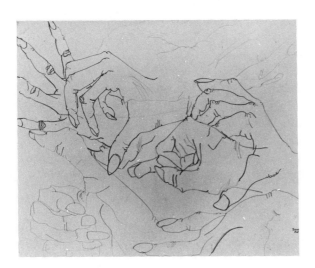

Pencil, crayon, pen, and ink were used in this blind contour. The exaggerations, a result of drawing blind, add character to the hands. Eventually, these exaggerations should be intentional. Student drawing by Susan Pops.

Remember: draw line by line. Don't look while your pencil is moving. Look at the page only to set your pencil down in relation to the previously drawn line. You must believe that the pencil point is touching your hand. Don't worry about the inevitable distortions and don't try to make a "good" drawing. This is an exercise in seeing.

Suggested Materials: 18 x 24 newsprint or bond paper, soft pencil.
Time: Several hours of *concentrated* work.

INTENTIONAL DISTORTION

After making numerous drawings of your hand, you should note the fact that the "distortions"—an unconscious result of drawing "blind"—often add incredible *expressive* power to your efforts. Your contour drawings are more *hand-like* than photographic renderings of the same form. Eventually, hundreds of drawings later, you'll arrive at a point where the distortions will become intentional. These conscious distortions will become a means of arriving at a personal statement: an expressive drawing.

DRAWING "BLIND"

Your contour drawings should be made "blind" for as long as you're able to maintain interest. No other exercise is as helpful in teaching you to *see* form so that later, when you allow yourself to look at the line as you draw, you can grasp the essence of every form. Even then, your eyes should be on the subject 99% of the time. And occasionally you should continue to create completely "blind" contours; this isn't a one-time exercise, but should become a continuing part of your drawing activity.

Make hundreds of these drawings and attempt to draw everything: hands, feet, machines, trees, flowers, room interiors, chairs, fruit, books, bottles, crumpled paper, drapery, all that lies within your vision.

Suggested Materials: Bond paper or newsprint; pencils in varying degrees; graphite sticks; ballpoint pens; crowquill pens; felt tip pens.
Time: The rest of your artistic life! But for the moment, several hours will suffice.

SOME SUGGESTIONS ABOUT CONTOUR DRAWING

Here are a few additional suggestions and ideas which will prove helpful to you in contour drawing.

Try to be *selective* in your drawing. Choose to delineate only those particular contours which *contribute* to the total form rather than detract from it. If you were to delineate *every* contour line you could see on your hand, the hand would probably look hundreds of years old (which you might even desire for an expressive purpose).

Occasionally it will help your drawing if you "cheat" ever so slightly. After all, you should draw not only what you see, but also what you know. The drawing of the thumb on page 22 illustrates this idea at points M and N on the fingernail. These two lines certainly help to characterize the thumb, but they definitely are not "feelable" forms.

Work very slowly in the beginning and try to understand the form as you

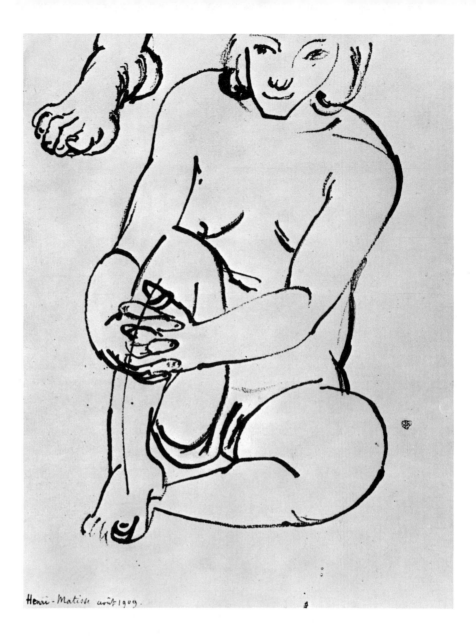

Henri-Matisse août 1909.

HENRI MATISSE
Woman Nursing Knee; A Foot
Pen and ink
11-13/16" x 9-7/16"
Courtesy, The Art Institute of Chicago
Gift, Mrs. Emily Crane Chadbourne.

It is believed that this drawing is an early study for an extremely large and important painting called, *Music.* It is interesting that many of Matisse's relatively "simple" drawings are achieved after a long and arduous series of studies, each becoming progressively less complex as he searches for the essence of a pose or gesture. None of the five figures in the finished painting contains as much detail as this preliminary work. The relatively arbitrary line running through the interlocking fingers and the lower leg is especially interesting in contrast to the rather large shapes defined by the rest of the drawing. That Matisse made a detailed study of the foot might indicate that he was not satisfied with the original drawing. I feel that the variety of shape, rhythmic flow and variation of line in the first drawing makes the detail study look inept by comparison.

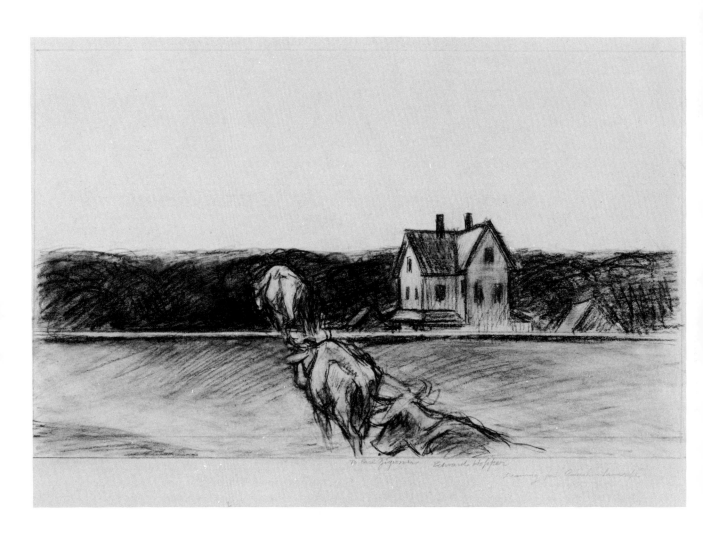

A whole history of art could be written about paintings in which cows serve as the subject. Even though Hopper is one of the great twentieth century realists, this drawing is contemporary in every sense of the word. It is contemporary because of the particular vision he brings to the subject. The subject is ordinary, perhaps even banal, but by the way Hopper composes the page he shows us an aspect of our environment in a new and unusual manner. The cows function not so much as three separate animals, but rather as three complex forms uniting to create a sweeping, diagonal curve which practically collides with the solid planes of the strong horizontals. Can you find other, more subtle, diagonals in this drawing? The horizontal movement is played like a "counterpoint" against the zig-zag rhythm of the buildings. Hopper leads us into the drawing, not so much with perspective, but because of the strong vertical movement moving up and into the page. Note that the sharpest dark and light contrast is where the third cow "collides" with the back plane. He cuts the form of the front cow the way Degas cut his dancers at the painting's edge.

EDWARD HOPPER
American Landscape
Philadelphia Museum of Art
Photograph by A. J. Wyatt.

"touch" it with the tip of your drawing tool. It takes a great deal of discipline to spend an hour or more on a single drawing of your hand. Yet this kind of concentration will ultimately prove extremely beneficial in your later work.

Work large. Try to make each drawing fit the page. Don't create a little spot in the middle or down in the corner. The drawn form should relate to the total page, comfortable, like an old pair of house slippers. Of course, slippers sometimes develop holes and a toe may stick out; this may also be true of a drawing where this is called "bleeding the edge."

Try to develop a quality of line which is expressive in itself—which has a life of its own—apart from the object or shape being delineated. Learn to exploit your drawing tools for all they're worth. See how many different kinds of lines you can draw with a single pencil by varying the pressure, rhythm, and speed. Note how the line quality of the Rodin drawing on page 52 and the Matisse drawing on page 25 are an integral part of the total form and expression. It would be impossible to create the Rodin drawing with Matisse's particular line quality; doing this would make the Rodin an entirely different drawing. Note that there's only the slightest variation in the quality of Rodin's line; but in this case, that slight variation is essential.

Almost anything can be the subject for a contour drawing. Drapery is excellent since the number of variations you can make with a single piece of fabric are endless. With a twig dipped in ink, the student drew on a very glossy paper. Drawing by an unknown student. Photo, Waggaman.

USE YOUR LEFT HAND Drawing with the left hand (if you're right handed) is difficult and requires a great deal of concentration. Nevertheless, it's a lot of fun. Set up a simple still life and do a blind contour as usual, but with your left hand. This is an excellent

exercise because it *demands* that you develop an awareness of "touching" the form. The motor coordination of right handed people is less refined in their left hand than in their right, and the forms created with the left hand will be even more distorted. This uncontrolled distortion, however, often results in some marvellously expressive drawing.

Suggested Materials: Newsprint or bond paper; since there's so much to cope with in this exercise, you'd better stick to the familiar pencil.

Time: At least one hour. I suggest that you repeat this exercise from time to time with a variety of motifs.

Drawing without looking at the paper is hard enough, but try to draw left handed and blind as this student did. Note how the material — oil paint, bristle brush on paper — influences the total form of the drawing. Drawing by Adele Unterberg.

BEGIN AT THE BOTTOM
Use a posed figure for this exercise. Rather than beginning the blind contour drawing with the head — as most people do — begin drawing the *feet* and work your way up. Make your drawing fill the entire page, reaching from very near the bottom to very near the top of the page. If, when you get to the top of the page, you discover that you don't have room for the head and shoulders because you made the bottom portion too large, simply condense the drawing, ignoring the distortion which will obviously result. Then, repeat the exercise, beginning in the abdominal region of the figure. These exercises force you to realize that there are many ways and places to "attack" a drawing.

Suggested Materials: Newsprint or bond paper; pipe cleaner dipped in India ink.

Time: Try to use a full hour for each drawing.

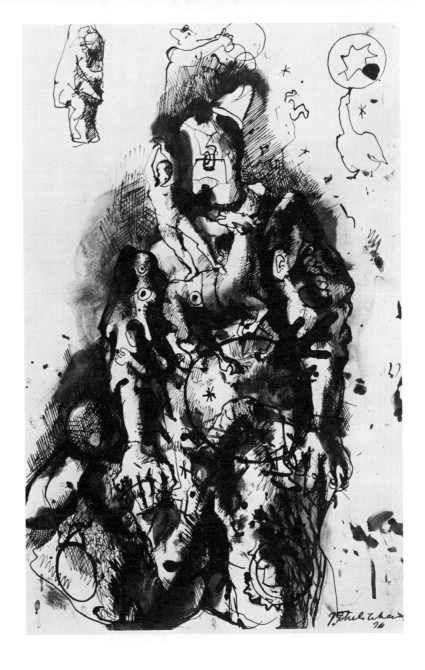

PAVEL TCHELITCHEW
Study for The Blue Clown
Wash, brush, pen, and ink
16" x 10-1/2"
The Museum of Modern Art, New York

The surrealists, exploring the world of the dream, were interested in creating an unusual juxtaposition of objects and in using metamorphic images. In this drawing, the forms within forms merge from one image into another until they finally add up to become *The Blue Clown*. Perhaps this imagery could be compared to the double exposures that one creates (all too often accidentally) in photography by shooting two scenes on the same film. The chest of the clown consists of a horse and rider; several figures appear on the right arm, and a face is on the left arm. How many other figures or portions of figures can you find? Why do the drips and smudges in this drawing seem to fit the over-all concept, yet in the Sheeler drawing on page 81 they would be considered out of place?

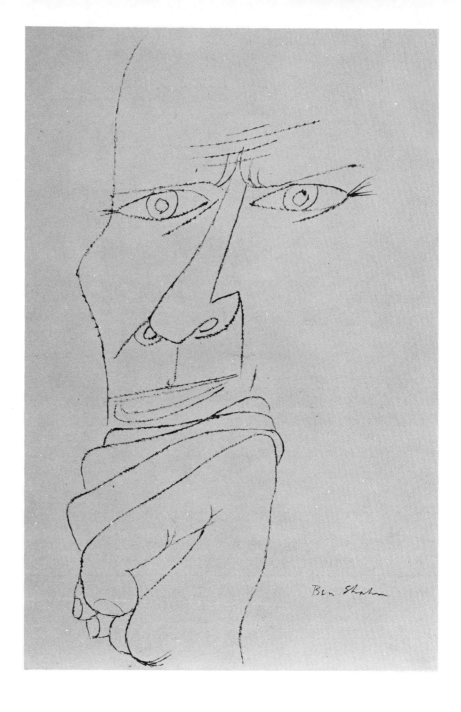

BEN SHAHN
Monroe Wheeler
Pen and ink
20-1/8" x 13-5/8"
The Museum of Modern Art, New York
Gift, Monroe Wheeler.

Shahn's art is often almost propagandistic in its support of the causes of minority groups. He has created some of the most powerful posters and illustrations of this century — illustrations which almost always transcend themselves and become fine art. As a photographer of the social ills of our society, Shahn often uses his photographs as the motif for his paintings and drawings. The distortions and simplifications in this contour portrait, which may verge on caricature, are carefully calculated to suit his expressive purposes. He has developed a hesitant and nervous line quality which is both unique and personal.

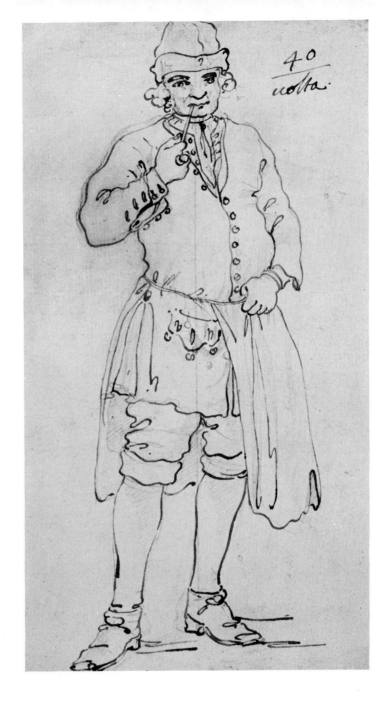

CANALETTO (ANTONIO CANALE)
Man Smoking A Pipe
The Metropolitan Museum of Art,
Purchase, 1939, Joseph Pulitzer Bequest.

This contour drawing has a nice rhythmic flow of line with slight changes in its value and weight. Notice the simple, almost schematic way in which he indicates folds. If you look closely at the drawing it is apparent that Canaletto sketched in the form very lightly before committing himself to the ink line. I generally try to discourage students from this practice, since they usually lose the spontaneity of a freely drawn line in the process. The four lines at the feet are enough to indicate that the background is a volume of space, rather than a flat surface.

DRAW WITH AN "ANT'S-EYE"

Ask your model to take a simple pose, preferably on a high stool or table, and draw her as she would appear if your eyes were on the floor — looking up — about two feet in front of her. This is a most demanding problem, which even advanced students find difficult since a tremendous amount of foreshortening is involved. The model's feet will be *very* large, the legs and abdomen will be very short, and the head extremely small. Although you actually see the *front* of the chin, you have to feel the *underside* of it. Instead of drawing the bridge of the nose — which is what you can *see* — you'll have to draw the nostrils as though you were almost directly under them. If a particular form confuses you, feel that area of your own body to understand the form. After several attempts at this "ant's-eye" angle, repeat the problem from a "bird's-eye"-view, where you have to imagine the model from an overhead angle. It might also help you to understand the foreshortening involved in this problem if you place a mirror on the floor and look down into it. You might try drawing from the mirrored image.

Suggested Materials: Newsprint or bond paper; 4B chisel-pointed pencil or Conté crayon.
Time: As long as your interest and concentration allows.

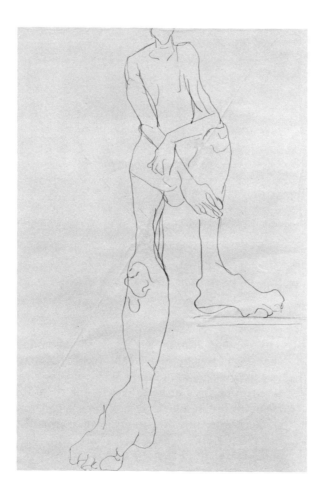

In this "worm's-eye" view, the student was asked to draw each form as it would appear if her eyes were on the floor beneath the model. This requires great foreshortening. Drawing by Jane Blumenthal.

WHITE ON BLACK Stand in front of a mirror and draw a full-length self-portrait with white ink on black paper. This is an interesting problem because the reversal of light and dark creates a dramatic effect which points up the importance of line as a means of defining form.

> *Suggested Materials:* 18 x 24 black poster board or construction paper (each has a distinct effect on the quality of your line); several Speed-ball lettering pens used to achieve a wide variety of line quality.
>
> *Time:* At least one hour.

Dramatic effects can sometimes be obtained with white ink or white Conté crayon on black paper. Student drawing by Leslie Fishman. Photo, Goldberg.

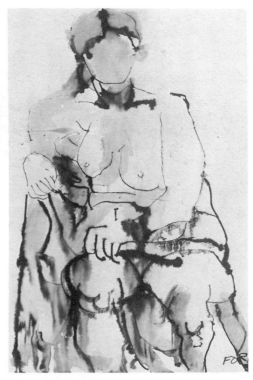

Interesting tonal effects and textures are obtained by moistening the paper before drawing with pen and India ink. The accidental effect can be somewhat controlled after a little practice. Student drawing by Kathleen Mittlesdorf.

WET THE PAPER In this exercise, you can use any motif, but I suggest that you arrange a piece of drapery into an interesting form by tacking it to the wall. Before proceeding with your contour drawing, moisten the paper with a sponge or brush. Actually, you can hold the paper right under the faucet to moisten it. Now proceed, using pen and ink on the wet paper. Depending on the degree of moisture (and I suggest

you experiment by moistening the paper from slightly damp to very wet), the ink will run and bleed, creating interesting patterns, forms, textures, and line qualities. At first, the results may seem overly accidental to you, but as you experiment you'll soon know approximately what to expect from the method and how to react accordingly. This is great fun!

Suggested Materials: 18 x 24 heavyweight drawing or watercolor paper; India ink; a variety of pens.

Time: As long as it takes to gain some control over this technique.

DETAIL STUDIES Occasionally, as you draw, you'll find certain forms giving you trouble. "It just doesn't 'feel' right." When you encounter this kind of problem in your drawing, it's a good idea to make a detail study of the form. Draw it large; fill the whole page with the form (even if it's only the eye-lid covering the eye-ball); try to make the detail become *the* drawing. Hopefully, you will not only create a work which is a drawing in its own right, but you will also understand the form which had been difficult within the context of the total motif.

Suggested Materials: Whatever you had been using in your original drawing.

Time: As long as necessary to arrive at an understanding of the form.

WHAT CAN A In this exercise, draw the view from your window. As you do contour drawings of
BRUSH DO? the view, exploit the unique qualities in the various brushes you have at your

This student exploited the particular qualities of her brush. The problem was to incorporate 3 collage elements with a contour drawing. Drawing by Adele Unterberg.

disposal. Make several drawings of the motif and compare the variations in form between all your drawings. Try using a #1 watercolor brush and India ink. Try a one inch varnish brush and India ink. Try a two inch varnish brush, white tempera paint, and large black paper. Try an oil "bright" brush and black oil paint.

Suggested Materials: #1 watercolor brush; one inch varnish brush; two inch varnish brush; #4 oil bright; India ink; white tempera; black oil paint; 18 x 24 drawing paper; 18 x 24 construction paper.

Time: Several hours.

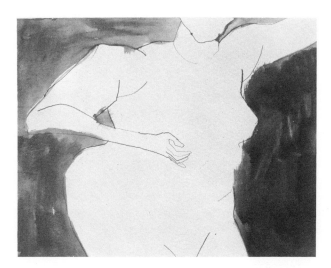

Here the student is trying to create a dynamic composition by fitting a vertical pose into a horizontal format. The tone in the background helps define the negative space, making those shapes important. Drawing by Michael Cohen. Photo, Waggaman.

STRETCHING A POINT

Even at the earliest stages, you will concern yourself with the problems of composition. The conventional procedure is to use a horizontal format to echo a horizontal motif. However, I find that *reversing* this procedure—using a horizontal format for a vertical motif and vice versa—develops a greater sense of composition. This is enhanced by a further restriction: the motif must come into contact with all four sides of the paper. This not only forces you to "fit" the motif within the given space but also, hopefully, causes highly expressive distortions.

Suggested Materials: 12 x 24 bond paper and graphite sticks.
Time: Try some relatively fast sketches (5 minutes) and also some sustained drawings (an hour or more).

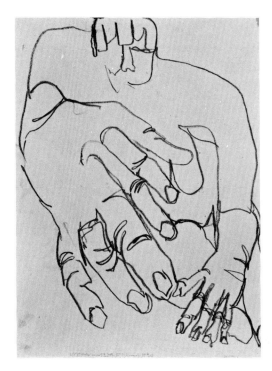

Scaling up a portion of the drawing can produce dramatic results. The problem was to draw a blind contour in which the hand would occupy about one third of the page. Student drawing by Deidre Channing. Photo, Waggaman.

"SCALE UP" On an 18 x 24 sheet — or better yet a 24 x 36 — do a contour drawing of your hand, large enough to fill the page. Don't look at the page while you draw. Working blind in this way forces you to scale up your drawing as you work. A line which, in actuality, is only three inches long may have to be made three or more times as long in your drawing. Some of my students have attempted this exercise on three by six foot sheets of paper.

Suggested Materials: 24 x 36 drawing paper; ¼" bristle brush; India ink.
Time: At least an hour.

MAKE PARTS WORK AS A WHOLE On an 18 x 24 page, make a contour drawing of seven hands posed in various positions. Try not to create seven separate spots or individual drawings, but make seven drawings which ultimately work together, or which combine to form a unified or cohesive whole on the page. This composition will no longer be a drawing of hands, but a new shape, a new form, a new invention which says something about "handness." Some hands may be large; some small; they may touch and even overlap one another.

This drawing will be even more successful if you make the background spaces — called *negative space* — function as an important part of the total form. The drawing should be so united that if you could pick up one of the "empty" negative spaces and pull it away from the page, the whole drawing and the other negative spaces would come along with it. The same is true of forms actually drawn (the hands, in this case), which in artistic terms, we call the *positive space.*

To make the problem even more complex, you might decide to combine sev-

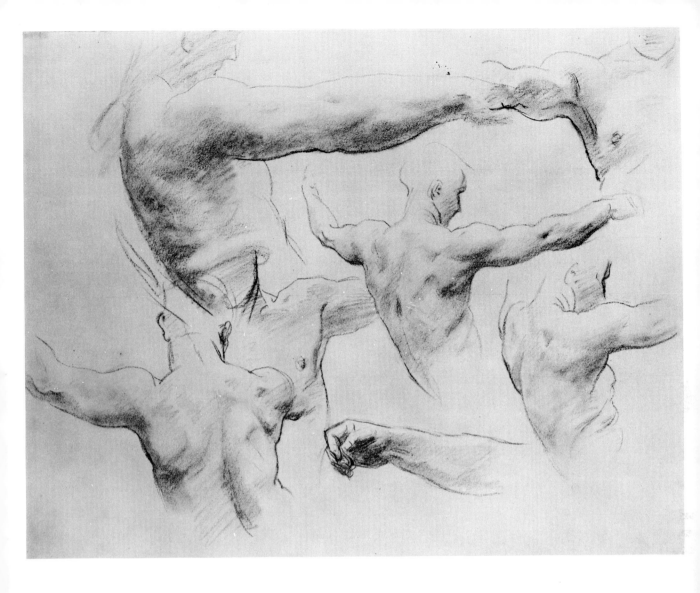

JOHN SINGER SARGENT
Action Study; Arms and Hands
Charcoal
19" x 25"
Philadelphia Museum of Art
Photograph by A. J. Wyatt.

This drawing merits our attention on two counts: first, the way it shows the structure of the back and arm, and second, for the way Sargent placed the seven studies in relation to each other and to the total page. Notice how the light falling on the figures is defined not only by the modeling of the form, but also by the variation of light and dark line. The line actually disappears on the head of the central figure to indicate a highlight without any modeling of form whatever! If you squint at the drawing you'll see how the positive and negative forms seem to flow in and out of one another, and how the positive forms overlap, creating the effect of transparencies and ground. This establishes a dynamic relationship between figure and ground. This organization undoubtedly was not arrived at in an intellectual way but rather intuitively. The single studies unite to become a form greater than the single parts. Note what a powerful effect on the negative space Sargent achieved by "bleeding" the edge of his format.

eral media in this one drawing; for example, pencil, twig and ink, pen and ink, and a felt tip pen.

Suggested Materials: 18 x 24 paper; pencils; twig; pen; India ink; felt tip pen.
Time: About three or four hours.

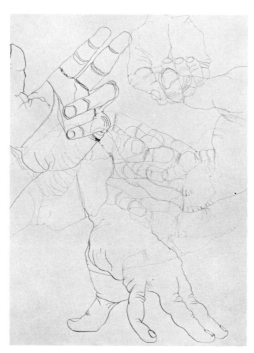

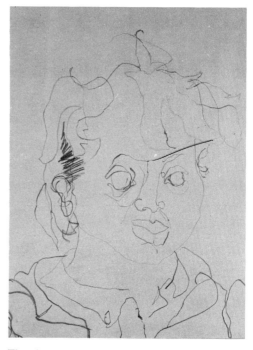

The problem here was to create a drawing of hands which would become more than a drawing of hands — the arrangement would in itself create an interesting form. Student drawing by William Harding. Photo, Waggaman.

The distortions in this blind contour drawing express much more about the subject than a slick, super-realistic rendering ever could. Note how the student looks for major rhythms in the hair. Student drawing by Phoebe Golden. Photo, Goldberg.

INNER-SELF-PORTRAIT Draw a self-portrait — from your reflection in a mirror — and try to capture *more* than the superficial characteristics of your face. Draw what you feel about yourself; attempt to work from within; create a portrait which reflects your mind and heart. Drawing a likeness is unimportant; the feeling or mood of the drawing should be its content. Try drawing a self-portrait with a pencil, another with black chalk, and still another with a one inch varnish brush and black tempera. Try yet another one where you combine *all* of these materials. Note that the mood you convey is related directly to the various materials and the way you use them.

Suggested Materials: 18 x 24 paper; pencils; black chalk; one inch varnish brush; black tempera.
Time: Try a dozen or so drawings, giving yourself only three or four minutes each. Then do a few in an hour or more.

**COMBINE
SELF-PORTRAIT**

Combine three different self-portraits on a single page. Refer back to the problem in which you drew seven hands on a single page. All three heads should combine to create a new form, a form in which no part could be removed without destroying the whole composition. Don't let self-portraits make you overly self-conscious; continue to draw with the confidence and determination you've been developing all along. Remember, the negative space is just as important as the positive space.

Suggested Materials: 18 x 24 paper or larger; use a complete range of pencils.
Time: This exercise could be a lifetime task, but several hours ought to prove quite beneficial.

ONG AND SKINNY

In a previous exercise, I suggested that you draw a horizontal motif on a vertical page and vice versa. At this point, I suggest you work on an odd shaped size of paper. For example, you could use a sheet of about 10 x 36 inches! For a motif, I again suggest a self-portrait, since the distortions necessary in utilizing all of the space on the page probably would not flatter a friend or relative.

Suggested Materials: 10 x 36 paper; #7 watercolor brush; sepia ink.
Time: One hour.

**COMPLEX
MACHINES**

Make a contour drawing of a complex machine, such as a typewriter, an electric fan, a telephone, or the back of a radio. Try to indicate every minute detail of the machine in your drawing.

A subject such as this will involve a lot of geometric forms which could make

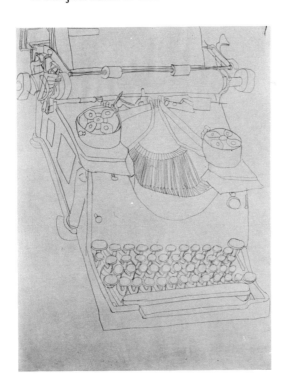

It requires patience and keen observation to draw the forms of complex machinery. Details of machines can become interesting drawings in themselves. Student drawing by Richard Batho.

for a rather stiff and static drawing, an effect which can be avoided by consciously distorting until you arrive at interesting and dynamic shapes. For example, circular keys lined up in rows on a typewriter could be quite monotonous unless you created subtle variations in their forms, producing a unity with variety.

Suggested Materials: 18 x 24 paper; variety of pen points and ink.
Time: Several hours.

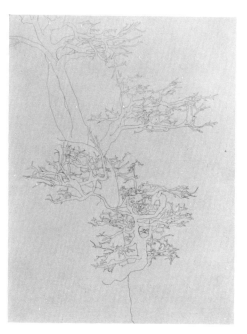

The student here carefully selects and balances complex areas of the drawing against less complex and open areas. Omitting one side of the tree trunk was an important decision. Drawing by Michael Cohen.

This effect was obtained on scratchboard. The student began this as a contour drawing and then elaborated it by working into the background. Drawing by Dianne Goodman.

LINE AND FOLIAGE Try a contour drawing of trees (or portions of trees if you think they'd make a stronger composition). Draw trees both with and without foliage. Naturally, foliage creates a tremendous problem in a line drawing since you obviously can't draw every single leaf on a tree (although I've had students attempt just that with amazing results). You must search for major forms and rhythms—just as you did when you drew hair—and almost "invent" a line to describe the forms.

It helps to change the quality of the line: use one kind of line for the foliage, another for the branches and trunk. Try this exercise with pencil or pen on white paper, and then repeat the problem on a scratchboard.

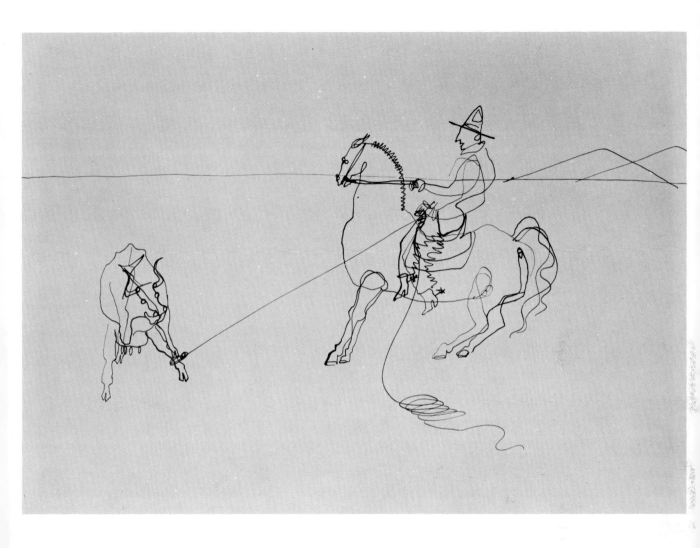

ALEXANDER CALDER
Rodeo Style
Philadelphia Museum of Art
Photograph by A. J. Wyatt.

Smile! And why not? There's no reason why the form and content of art must always make a profound statement; art can be fun, too! Though best known for his mobiles, Alexander Calder also does drawings worthy of attention. Have you ever seen a cow with as much character? See Hopper's drawing on page 26. Does Calder's drawing have any relationship to the drawing by Duchamp on page 14? Of course, the joy of this work is communicated by the *almost* continuous character of the line, as it wobbles, accents, twists, and turns. They all spell "Rodeo Style."

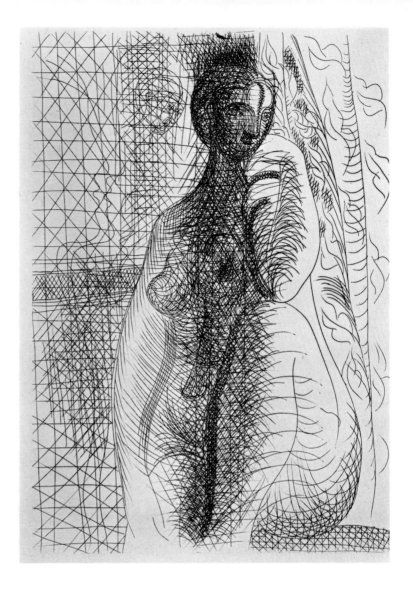

Whether it's legitimate to reproduce an etching in a book concerned with drawing is open to question. Etching is a graphic process. The artist draws on a treated metal plate from which he can produce hundreds of the original. Actually, drawing is drawing whether it's produced with a pencil on paper, a brush and oil on canvas, or an acid-etched line on a metal plate. This etching illustrates the concept of cross-contour drawing. Picasso leaves the outside contour and pulls the lines *across* the body to describe the form existing *between* the outside contours. Simultaneously, he creates lights and darks which model and help to define the form. Note how the horizontal and vertical lines of the background are super-imposed on the cross-contour modeling of the figure in the dark, central area. Also note how he incorporated four contour figures in the background and how this area on the left contrasts and complements the flowered drapery on the right. Which area of the drawing did Picasso want to be dominant? How many tones of gray has he achieved?

PABLO PICASSO
Femme Nue á la Jambe Pliée
Etching, G. 208
12-1/2" x 8-1/2"
Philadelphia Museum of Art
Photograph by A. J. Wyatt.

Scratchboard — easily obtained in any art supply store — is a bristol board with a clay coating. In order to prepare the surface, you simply cover it with India ink. When the surface is dry, you scratch into it with a variety of implements, creating a white line on a black ground. Though scratchboard is generally used as a commercial art technique, it has an untapped potential as a fine art medium.

Suggested Materials: 9 x 12 white paper; pen and ink; scratchboard and various scratching implements — knives, razor blades, pins, etc.
Time: Three hours.

CONTINUOUS LINE CONTOUR

A continuous line contour drawing involves the same attitude and approach you developed in the previous problems, except that your pencil should never leave the paper. Your pencil is in continuous contact with the paper and simply moves in, through, and around the form.

Make a continuous line contour drawing of a figure. If, after working from the head down to the feet, you want to draw the head again, you have to draw your way back up the form. You can "draw" your way back along the apparent edge of the contours or even right up through the middle of the form. A line describing a form this way is sometimes called a *cross-contour* drawing. Try a continuous line drawing with your left hand. Then do a drawing in which you work "out" from the center of the figure in all directions. Over-emphasize, or even consciously *distort* the movements of the figure in order to clarify "what is happening."

Repeated over and over again with a great variety of motifs, this exercise forces you to see and feel and to delineate form where there is no obvious "edge" to follow. (See drawing on page 36.)

Suggested Materials: 18 x 24 paper; your choice of linear drawing implements.
Time: Do these the rest of your life. Practice now for a few hours.

IN A CORNER

Draw the corner of a room. Part of the problem is selecting an interesting corner, one with contrasting shapes and lines. "Picturesque" may be an applicable term here, though it suggests a certain sentimentality which may not be desirable. For example, you have to be exceptionally talented to make a good drawing of the Seagram Building in New York City. On the other hand, a Greenwich Village brownstone probably suggests a much wider range of forms which you can accept or reject. The same principle applies in selecting a corner of your room. Attempt to make your line "say something" about the various textures you encounter.

Suggested Materials: 18 x 24 paper; crowquill pen and ink.
Time: One hour.

SEVEN FEET

Repeat the "seven hands" drawing, this time using feet instead of hands. Also try to use seven different brushes, including a one inch varnish brush. To draw a row of toes with the brush demands a great deal of selectivity.

Suggested Materials: 18 x 24 bond paper; seven different brushes; India ink or black tempera paint.
Time: Three hours.

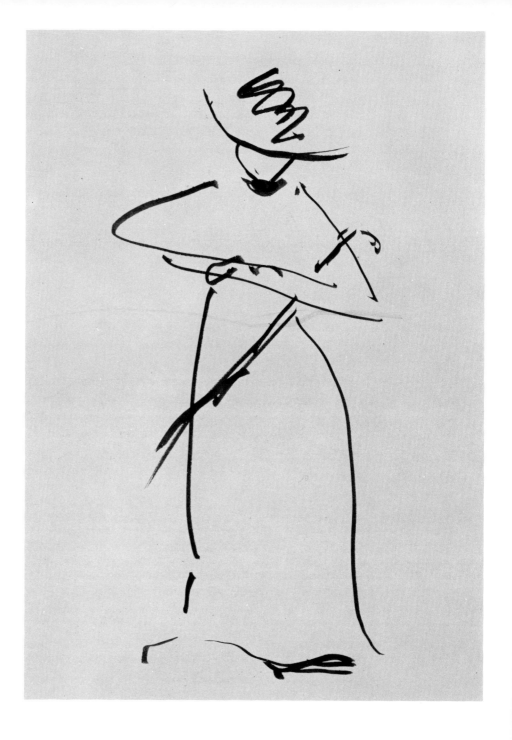

ALBERT MARQUET
Woman with Umbrella
Brush and ink
11-1/8" x 7-1/2"
The Museum of Modern Art, New York.

Though a modern artist who was a member of the *fauve* group (which literally means "wild beasts"), Marquet, like most modern painters, spent many hours in the Louvre studying masters such as Chardin, Claude Lorrain, and Poussin. Like so many painters, Marquet might very well be remembered longer for his mastery of line than for his paintings. He makes a quick decision and then, with incredible economy, captures the essence of a pose or gesture; one stroke of the brush becomes a foot; a wiggily scribble becomes a feathery hat.

3 quick contours

After many hours of practice with regular contour drawing and after you have disciplined yourself "to see" form, you should progress to quick contours.

WHAT ARE QUICK CONTOURS? The approach you use here is similar to the approach you used in regular contour drawing. However, rather than moving very slowly and cautiously — studying each individual form — you draw quick contours rapidly. Now you will look for meaningful lines which quickly reach to the essence of the total form you're drawing. Simplification is a key word. Look through the mass of unimportant detail and select those few lines which, when put down with *conviction*, and with

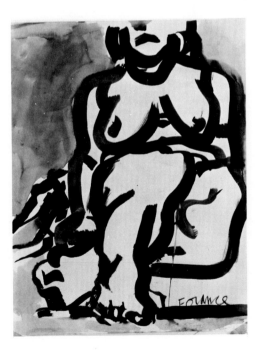

Details cannot be elaborated in a quick contour. Using a very large brush forces you to seek out the major contours. Student drawing by Kathleen Forance.

powerful relationships to one another, communicate the essential structure and meaning of the whole subject. Quick contours are a type of shorthand, since the complete pose or the total object can be *read* even though only a small portion of it is indicated. In artistic terms, we refer to this phenomenon as *closure.*

In many ways, quick contours resemble gesture drawing—the method covered in the next chapter—but in quick contours you use a single, convincing line in which you absolutely believe, rather than a sketchy line.

SUBJECTS AND MATERIALS FOR QUICK CONTOURS

Although a live model is probably the best subject to use for this exercise in quick contours, any object will suffice. Organic materials, such as flowers, trees, and driftwood, also serve as excellent subject matter.

Although you should be able to execute quick contours with resistant drawing tools, such as pen or pencil, you'll probably find it easier to eliminate meaningless detail by working with a brush. A long-haired watercolor brush demands a certain delicacy of touch; one or two inch varnish brushes force you to be bold and to "say more" with the line than the delicate line of small brushes, pens, or pencils.

Practically everything happening to the model is described here with a half dozen lines. The addition of several tones helps to pull and push the figure in and out of space. Student drawing by Gladys Comart.

YOUR APPROACH

Try a great variety of approaches and materials. Start with five minute sketches and gradually work down to five or ten second sketches and back again to the five minute sketch.

Train your eye to arrive quickly at the major movements and rhythms of the figure so that your hand will respond almost automatically.

Don't worry about the art quality of your first hundred drawings; this is an exercise and there will be enough time to make "good" drawings after these initial experiences.

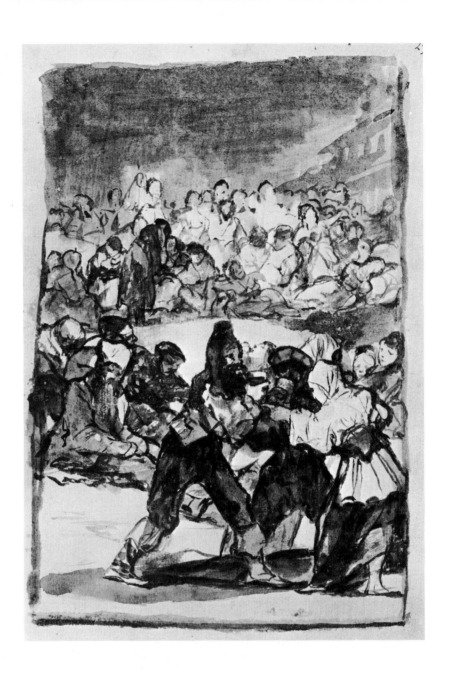

FRANCISCO GOYA
A Crowd In A Circle
Wash drawing in sepia.
8-1/8" x 5-5/8"
The Metropolitan Museum of Art.

The content of Goya's work necessitated a style which often verged on caricature. In this drawing, the burden of the content is carried through the juxtaposition of contrasting tones. Note how he has indicated a vast crowd of people in the background without really defining a single individual figure. Space is suggested through diagonal movements, vertical placement of planes on the page, overlapping, atmospheric perspective, and — most important in this drawing — diminishing detail. The crowds in the background have no features and yet the strong dark accent on top of several heads tends to pull this far plane back to the flat surface of the picture plane. The principal central figure, through overlapping, not only creates space but helps to relate the background and foreground planes.

47

JOHN FLANNAGAN
Nude, 1938
22-1/2" x 12-1/8"
Philadelphia Museum of Art
Photograph by A. J. Wyatt.

Flannagan is best known for his sculpture. He creates sculpture which relates to reality without destroying the essential rock-like quality of his basic material. Flannagan's sensitivity to material is carried over into this monolith-like drawing which almost shouts, "Look at me, I was created with a brush…but I am also a woman!" It's impossible to separate the form from the material which created it. Placing a figure in the middle of the page in this way is something students are prone to do and their drawings are usually very static. Why isn't this true of Flannagan's drawing?

SEARCH FOR STRUCTURE

Set up a relatively complex still life and make a long, careful blind contour drawing of it, using a bamboo pen and sepia ink. Study and draw every minute detail of the still life. Try to spend at least a full hour on this drawing.

Next, draw the same still life in thirty minutes, eliminating unimportant details and beginning to distort and exaggerate consciously, moving forms about in your drawing to achieve a meaningful or coherent structure. Next, in a ten minute drawing of the still life — using a one inch or two inch varnish brush — try to make brush strokes which not only describe the still life, but brush strokes which are beautiful in themselves. Now do a five minute drawing.

Finally, attempt several dozen one minute drawings, continuing to indicate the essential structural forces and tensions operating in the still life. In each of these one minute drawings, use a different drawing material.

Suggested Materials: 18 x 24 bond paper; sepia ink; bamboo pen; India ink; 1 x 2 inch varnish brush.

Time: Three to four hours.

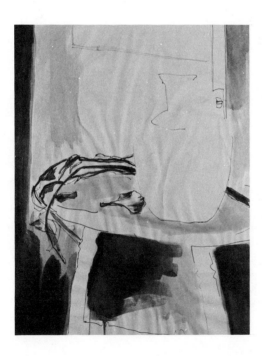

Two carefully selected lines describe an entire vase! Note how form is defined both by line and by one tone meeting another tone. What might have been a rather ordinary line drawing is transformed into an exciting form by adding a strong light and dark structure of washes. Student drawing by Palma Rovetto.

QUICK CONTINUOUS LINE DRAWING

For this exercise, use a model or pose yourself in a mirror. Approach the drawing with the same attitudes and manner of observation you developed in the previous exercises, this time without picking up your pen from the surface of the paper until the drawing is completed! If you find that you've drawn down to the feet and haven't yet finished the features in the face, draw your way back to that area. In drawing back, you can follow the edge of the figure or you can draw the interior of the form, letting your line describe the form as it "touches" it.

Think of a fly that's been dipped in ink as it walks over the torso. How would the ink line look as the fly moved up and down the convexities and concavities

of the torso? This is precisely the line that you should be "feeling" or drawing in this exercise. Try a continuous line contour as both a regular and a quick contour drawing.

Suggested Materials: 18 x 24 newsprint or bond paper; several drawings with a bamboo pen and ink; several with a lithographic crayon.
Time: Between two and four hours for this exercise, but continue to produce hundreds of continuous line drawings in your sketchbook wherever you go.

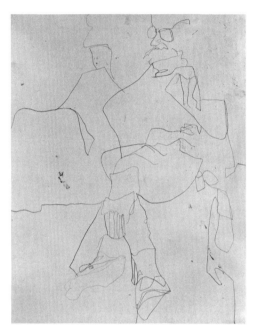

Working left handed, blind, with only 5 minutes to draw are pretty severe limitations! Note that the line is almost continuous. The student has made the entire space of the page important. Drawing by Judith Gnagnarelli.

Using a 1 inch brush and ink, the student has described the gesture of the figure and has also organized the entire page with just 2 brush strokes. Drawing by Jill Rader. Photo, Waggaman.

MAKING A LOT OUT OF LITTLE

Have you "caught on" to the features of quick contour drawing; the rather abstract quality of the image; the way the relationships of lines to each other "activate" the page? If so, as an exercise you should now reduce — to the severest economy — the number of lines you use.

Using a one inch varnish brush, some ink, and only *five* lines, show what is happening to the figure or still life and, at the same time, compose the total page. Next, use only four lines; then, three lines, two lines, and finally use only one line! This is most difficult. The whole page should "work," which means that every aspect and area of the drawing should support the whole. There must be a marriage of figure (brush stroke) and ground (the white page surrounding the

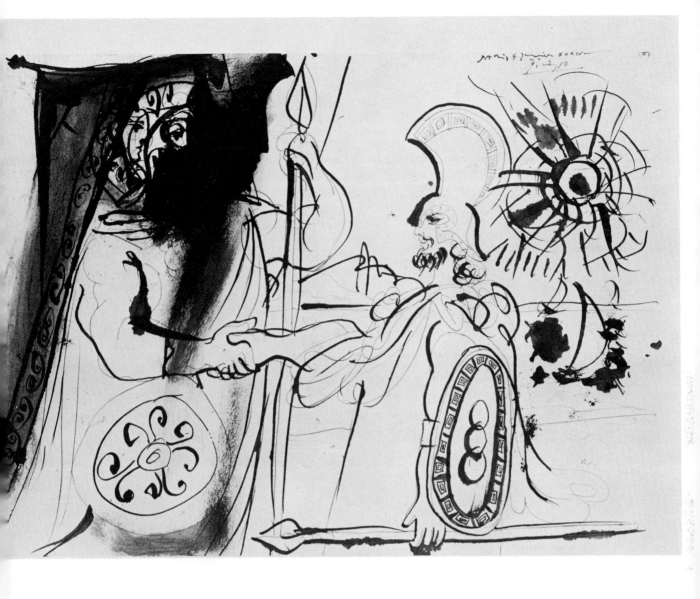

PABLO PICASSO
Study for Lysistrata Illustrations
9-1/2" x 13-1/4"
A. E. Gallatin Collection
Philadelphia Museum of Art.

This drawing is a marvelous illustration of severe, disciplined line functioning with a spontaneous gesture. Note the careful contour drawing of the arm and head — obviously drawn first — and how the freedom of the line he draws over them practically negates their existence. He is able to repeat the circular shape of the shields and sun with the infinite variety characterizing his work. The repetition of elements such as line, shape, texture, or tone, help organize the page. Note also how important the bottom, horizontal spear is in "anchoring" the whole drawing. The multi-portrait on the left — with its cast shadow — becomes more positive and clearly defined than any shape in the drawing because of the sharp light and dark contrast. This sets up a psychological tension equal to the vigor of the total drawing. Picasso pulls the dark of the shadow across the body and down around the shield, a movement which, echoed by the vertical spear, almost splits the drawing into two distinct areas.

AUGUSTE RODIN
Three Crouching Women
Pencil and watercolor on paper
10-1/2" x 14-1/4"
Rodin Museum, Philadelphia
Courtesy Philadelphia Museum of Art
Photograph by A. J. Wyatt.

Because of his superb drawings, Rodin would be a master even if he never produced a single piece of sculpture. Three figures? I suppose so; but what an incredible form-invention! Why would a man with Rodin's incredible facility be satisfied with the relatively careless drawing of the feet in this work? Obviously, he conceived the feet very rapidly; they were of minor importance in relationship to the over-all, new form he was creating. This is much more than three figures; it is a new shape; a form-invention; a "marriage" of three figures utterly and totally dependent upon one another for their existence. The rhythmic quality of the line is complemented by the three dark spots which organize the drawing by their proximity and similarity of tone. Repeating the direction in the large masses also helps to establish an underlying compositional structure. To a beginning student this drawing may appear "simple." After your first few hundred it will, in fact, look more difficult!

figure). Try to make your brush respond to your every touch and nuance. This severe use of line can "say more" (be more expressive) than a very complex drawing.

Suggested Materials: 18 x 24 bond paper; one inch varnish brush and a #12 camel hair brush; India ink or black tempera paint.
Time: One hour, but repeat this exercise at regular intervals.

MORE THAN THE MODEL Have your model take a whole series of five minute poses, and for each pose produce quick contour drawings on a single 18 x 24 page. Relate each new pose to the previous one and to the page as a whole. Don't stop drawing until the whole page is an exciting form, a form which is more than the sum of its parts. The form you create should consist of lines, shapes, and tones derived from each pose, but transcending them as individual poses.

The point can be illustrated using your hands as an example. Observe one of your hands (the equivalent of one quick contour drawing of the model). Now observe both your hands (two quick contour drawings). Now lock the fingers of both hands together and twist your hands as far as they will go, an action producing a new form which transcends mere "handness" and becomes something much larger than the individual hands. The problem of constructing a total form — independent of the individual elements — is difficult and one worth trying over and over again.

Suggested Materials: 18 x 24 drawing paper; pencils; pen and ink; felt tip pens.
Time: This exercise should involve several hours on each page.

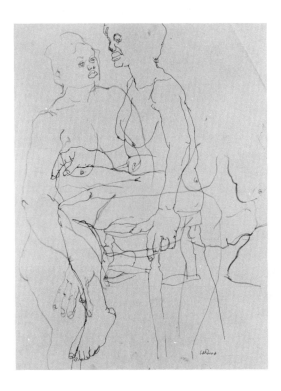

The student attempted to arrange 3 five minute quick contour drawings on a single page. Overlapping the forms helps to unify the 3 poses. Drawing by Joan LaRocca.

MAKE THEM LARGE! For this exercise, cut several five or six foot lengths of paper from rolls of 36 inch (or wider) brown wrapping paper and tack or tape the pieces to a wall. Have your model take ten minute poses, during which time you'll create quick contour drawings using a two or three inch varnish brush and black and white tempera paint. Draw some of the lines with the white paint and other lines with the black, using a brush loaded with paint. These lines should be very loose, bold drawings in which you try to achieve a nice tension or contrast between the white and black strokes. As you progress through a dozen or more of these drawings, you might try several where you draw simultaneously with a brush in each hand.

After finishing all the drawings, go back to them to see if any could be improved by adding some large areas of gray in the figures or the backgrounds. There is a certain sense of drama about working large like this, as if you were performing a dance on a very large stage, attempting to use all the stage space at once. Needless to say, details—such as left eyebrows—hardly have a place in these drawings.

> *Suggested Materials:* 36 inch wide rolls of brown wrapping paper; two inch and three inch varnish brushes; black and white tempera paint; container for water; palette.
>
> *Time:* As long as it takes to produce a dozen drawings which satisfy you. This may mean doing fifty or sixty!

THE MOVING MODEL You'll enjoy this exercise because it allows you wide latitude to invent your own form. Have your model change her pose just slightly about every thirty seconds while you do quick contour drawings of her. Obviously, you won't ever have time to finish an individual pose, so you'll have to concentrate on selected aspects

This drawing was created from a model in continuous motion. The student had to select a form here, a form there, and also relate each line to each previous line. If you look carefully, you'll see specific forms. Drawing by Barbara Polny.

of each pose, a selection which you make not only on the basis of the pose itself, but also in relation to the drawing you've already done on the page. In effect, you're drawing parts of the body and composing your page simultaneously. You're not drawing a single pose, but lines which say something about the changing contours of a moving figure.

You can repeat this problem by having the model change poses very slowly without ever coming to a definite halt. The model will be in continuous motion.

Suggested Materials: 18 x 24 drawing paper; a variety of drawing materials; pencils; graphite sticks; Conté crayon; marking pens.
Time: According to the demands of each drawing, from ten minutes to several hours.

GROUPS AND CROWDS OF PEOPLE

Go out to a bus station, train terminal, or other public place where groups of people are standing or sitting about waiting. Naturally, a group of four or five people sitting in a waiting room won't be stationary for more than a few seconds at a time, so this forces you to move rapidly, searching out the major contours and rhythms. Your contour line becomes a kind of invented shorthand which describes much more than it actually delineates.

Try this exercise with large groups of people. The rhythm of the moving crowd might be easier to achieve by using a continuous, flowing line such as you used in one of the previous exercises.

Suggested Materials: Your sketchbook; an artist's fountain pen filled with black drawing ink.
Time: Two or three hours.

DRAPERY AND FLOWERS

The folds and twists in a large piece of fabric are an excellent motif for quick contour studies because just a slight touch or push of the fabric changes the contours radically from drawing to drawing. You can tack the drape to the wall, lay it on the floor, or pile it on top of various objects, such as chairs or stools. After studying the structure of drapery, with rapidly drawn contour lines, you might want to change the motif slightly by introducing a vase of flowers.

Suggested Materials: 18 x 24 drawing paper; the complete range of your drawing pencils so that you can achieve lines of varying tonality.
Time: Two or three hours.

GO BACK

Almost all of the problems suggested in the preceding chapter on contour drawing are also excellent exercises for achieving quick contour drawings. I suggest you go back and try them over again in this new technique, the quick contour.

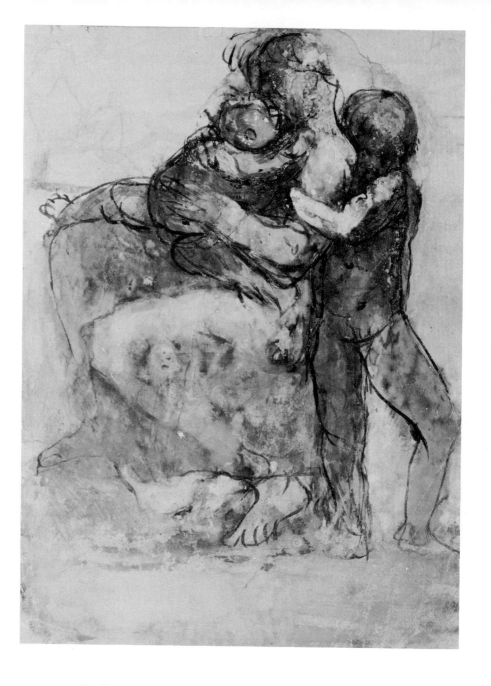

AUGUSTE RODIN
Woman and Two Children
Gouache on paper
7-1/8" x 5-1/8"
Philadelphia Museum of Art
Photograph by A. J. Wyatt.

Rodin was not only one of the greatest modern sculptors, but also a master draftsman. This poignant drawing reflects the lively, light-reflecting surfaces of his sculpture. The light never stands still; it shifts and bounces in an arbitrary fashion. The quality of light is enhanced by the line, which seems to be performing a never-ending dance. The line simultaneously defining both the right side of the child and the mother's skirt is interesting in its equivocation. Note how we're able to "read" the leg beneath the skirt and also how it seems to "bleed" into the ground. Why didn't Rodin indicate more precise detail? Note also the "echoing" of a line in the standing child's body and the mother's arm and the fact that the mother has two left feet. Can you find other occurrences of this phenomenon?

56

4 gesture drawing

Gesture drawing is completely opposite from contour drawing. In contour draw-ing, you arrived at the whole form through studying and relating individual forms; you moved from the part to the whole, using a single, precise line. In gesture drawing, you move from the whole to the parts, using a rather sketchy or even a scribbly line. Gesture drawing is, however, closely related to quick contours, because both are created with great speed.

WHAT IS GESTURE DRAWING? The object of gesture drawing is to grasp the essential gesture (that is, move-ment or disposition) of the model almost instantaneously. While marking the paper, you allow your hand, your arm, your *total being* to respond to the model. Your drawing is a *visual* counterpart of your total identification with the pose. You're not drawing the *model*, but the model's *action*: the swing of the body and limbs, the distribution of the weight translated into a linear and tonal language.

This is sometimes called *action drawing* and sometimes *scribble drawing*, un-fortunate terms since they denote random, aimless marks which have no mean-ing. The spontaneous quality of the scribble, its free-wheeling attitude, is, however, related to gesture drawing. Although the line is free and spontaneous, it also describes what is happening to the figure.

LOOSENING UP You may find it difficult to make a transition from the discipline of straight con-tour drawing to this relatively loose kind of drawing. If so, try some very fast sketches, from five to ten seconds. Keep your eyes on the model 98% of the time while you're drawing, and put one drawing right on top of another; the page will eventually end up as one big scribble. Remember, this is an exercise.

If you're working with an instructor, he may occasionally ask you to change to a new page and have you put only one drawing on it; he may then ask you to change the procedure again by having you put on several; then back to a single drawing again. Varying the procedure in this way makes you respond with your

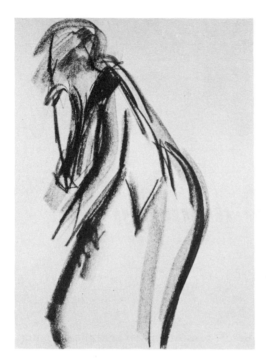

This gesture drawing in black chalk was produced in 10 seconds. With just a few strokes, the student indicated the major movements of the body. Note how he modified the initial gesture for the head. Given more time he would've elaborated even further. Drawing by Stephen Sugarman. Photo, Goldberg.

whole being and prevents you from being inhibited by a conscious attempt to make a "good" drawing. If you're not working with an instructor, consciously try to vary your approach on your own.

Start with rapid sketches and gradually extend the time to twenty second drawings, thirty second, sixty second and eventually to five or ten minute drawings. The attitude and attack remain the same. Put down the essential gesture in the first few seconds and in the time remaining develop the drawing to a greater degree: the gesture of the toes, fingers, facial features, and hair. Also refine the "edge," which may be rather ambiguous since it consists of so many lines. The general proportions may also be refined.

Suggested Materials: 18 x 24 newsprint paper; black chalk or compressed charcoal.

Time: Spend several hours at this time and more in the future. You might begin *each* of your drawing sessions with a few gesture drawings.

DOUBLE THE GESTURE

Generally, by almost doubling (exaggerating) the gesture or action of the figure, you will approximate the pose as it actually is in your drawing. Most of us tend to stiffen the pose. The initial gesture drawing should provide enough information about the pose so that you can finish the drawing without the model.

MATERIALS FOR GESTURE DRAWING

A non-resistant or soft drawing tool is best for gesture drawing: chalk, Conté, charcoal, or oil crayon. You can obtain a combination of linear and tonal qualities by using the side as well as the tip of the material. After you've done a few

exercises in gesture drawing, and you have a feeling for the technique, you might change to a more resistant material, such as pencil or ink.

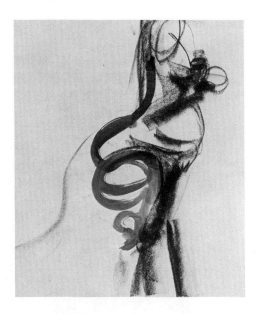

The student was allowed only 5 seconds to indicate the gesture with brush and sepia ink, then 10 more seconds to develop the action further with black chalk. Drawing by Sheila Golden.

ASSUME THE POSE Just before the model takes a break, have her strike a very "active" pose. Then assume the identical pose; tense your muscles to feel where your weight is; feel the direction of your shoulders and hips; notice the relationship of your feet to each other and to the angle of your head; note the bend of your elbows and fingers; try to "pull" on the muscles essential to the pose. After you've done this, ask the model to step down, and then see if you can draw the pose from memory.

On another occasion, after a similar preparation, try a gesture drawing from another viewpoint: as if you were on the opposite side of the room; or again, as if you were sitting on the ceiling *above* the model, an angle which forces you to foreshorten all the forms.

Suggested Materials: 18 x 24 drawing paper; compressed charcoal.
Time: Ten to fifteen minutes for each memory drawing.

COMBINE GESTURE AND CONTOUR DRAWING Make a gesture drawing of a posing model or of a still life. Then, on the same page using the same pose, make a *contour* drawing with a different material directly on top of, and in relationship to, the gesture drawing you just completed. The contour line you produce will arise not only from observing the model, but also from observing the gesture drawing. Your second drawing will be conditioned and dependent upon both elements.

Suggested Materials: 18 x 24 drawing paper; earth colored chalk or pastel for the initial gesture; chisel-pointed pencil or marking pen for the contour drawing.
Time: At least thirty minutes for each page, but try several drawings.

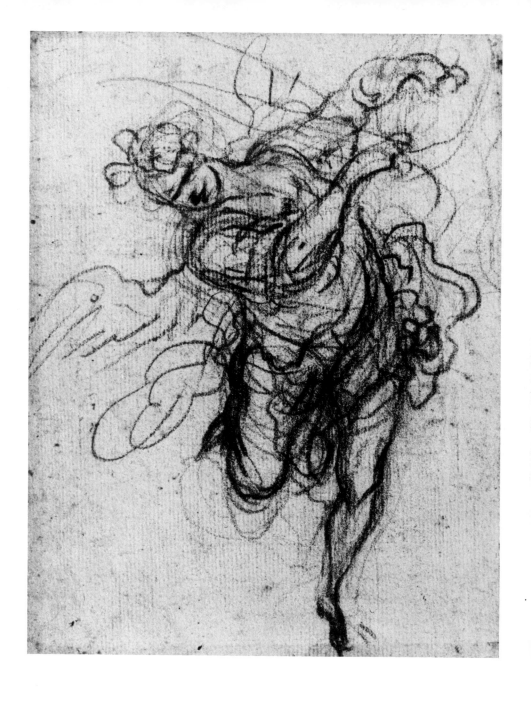

JACOPO da PONTORMO
Dancing Figures
Red chalk
The Metropolitan Museum of Art,
Gift of Cornelius Vanderbilt, 1880.

Fresh! Alive! Exciting! Dynamic! The swirling lines and rhythms in this gesture drawing of a dancing figure almost dance right off of the page! Pontormo moves his chalk in, down, through, and all around the gestures of the moving figure. This is not so much a drawing of *a* figure as it is a graphic representation of the figure's *movement.* Note how a line repeats and seems to echo itself as the artist searches for greater and greater definition of the pose, giving the image the effect of almost growing out of the page. The image is so intimately related to the page that it would be impossible to cut the figure out with a pair of scissors. Which of the many lines would you decide to cut along?

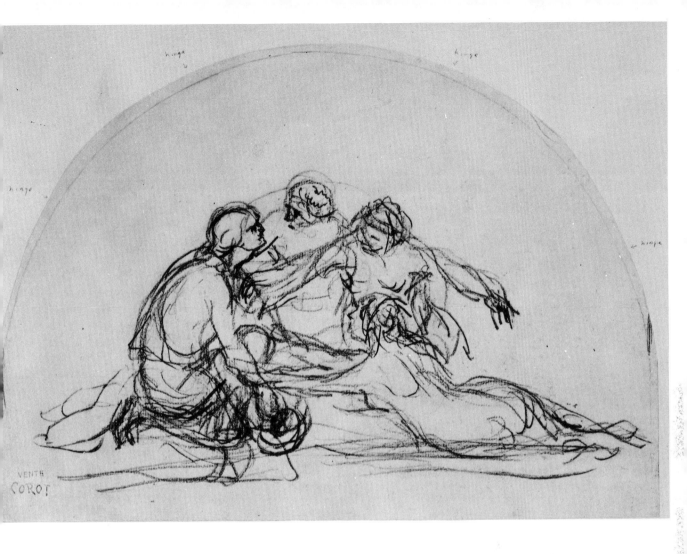

JEAN-BAPTISTE-CAMILLE COROT
Three Nymphs and A Youth,
study for a decorative lunette.
Black chalk
8-7/16" x 12-3/8"
The Metropolitan Museum of Art,
The Elisha Whittelsey Collection, 1962.

Though Corot is a master, it is interesting how stiff, rigid, and almost clumsy this drawing is compared to the Pontormo on the page opposite. The lines in this drawing flow (more or less) only along the long contours of the figures, whereas the lines in the Pontormo flow back and forth across the body in all directions. That Corot conceived of his figures in a stationary position while Pontormo was capture the movements of a dance may account for some of the difference. Fitting a group of figures into an unusual format such as this is a difficult problem and you can see how Corot tried to echo the curve in his grouping—he even swung in an arbitrary line through the three heads.

TWO HUNDRED GESTURES! Go to a park, a bus depot, or some similar place where people are constantly passing. Sit down for about one hour and in this time see if you can create about two hundred gesture drawings. Use pen and ink or pencil and make your drawings fairly small, about two or three inches for each gesture. People in motion force you to capture the essential gesture in the first two or three lines.

Suggested Materials: Sketchbook; artist's fountain pen; pencils.
Time: One hour, but repeat the essential nature of the exercise periodically.

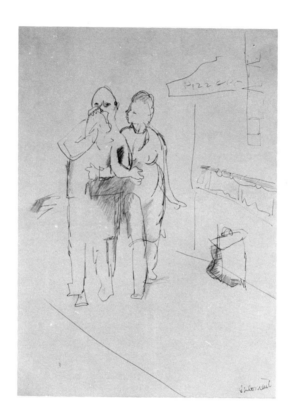

Trying to capture the gesture of people as they walk past on the street forces you to search for the essence of the movement. Student drawing by Gladys Comart. Photo, Goldberg.

INANIMATE GESTURES After the preceding problem — in which you did two hundred gesture drawings — you should be pretty well "loosened up," a good time to practice gestures of the inanimate objects surrounding you. Draw automobiles, baby carriages, bicycles, typewriters, musical instruments, waste baskets, benches — in fact, draw everything you see around you. Drapery is a very good motif, since its "pose" can be changed as radically as that of a live model. Continue drawing with the same attitude of loose abandon and confidence that you developed in the previous exercises.

Suggested Materials: Sketchbooks; pencils; pens; pipe cleaners; ink.
Time: No limit, your sketchbook should be filled with hundreds and hundreds of such drawings.

(Left) India ink, pen, and brush were used here to indicate the gesture of inanimate objects. This still life was set up at eye-level and the student had to imagine how it might look if she were viewing it from a "birds-eye" view. Drawing by Janet Freeman. Photo, Uht.

(Below Left) 25 seconds is all this student had to create this powerful gesture drawing. She used a dry brush effect with a one and a half inch brush and black ink. Drawing by Enid Glaser.

(Below Right) Here the student used brush strokes and washes to indicate the gesture in a 20 second pose. Drawing by Marilyn Silverstein.

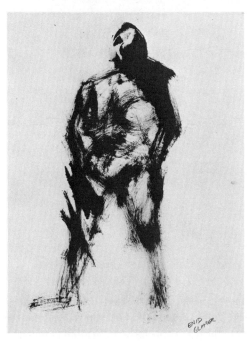

LARGE BRUSH GESTURES

Try some gesture drawings using a large one or two inch brush with black tempera paint. Because you're working with such a large brush on a relatively small piece of paper, you're forced to see through the maze of detail to the masses constituting the pose.

You will enhance the gesture greatly if you produce a calligraphic quality in your brush strokes — each stroke becomes, in and of itself, a beautiful form which

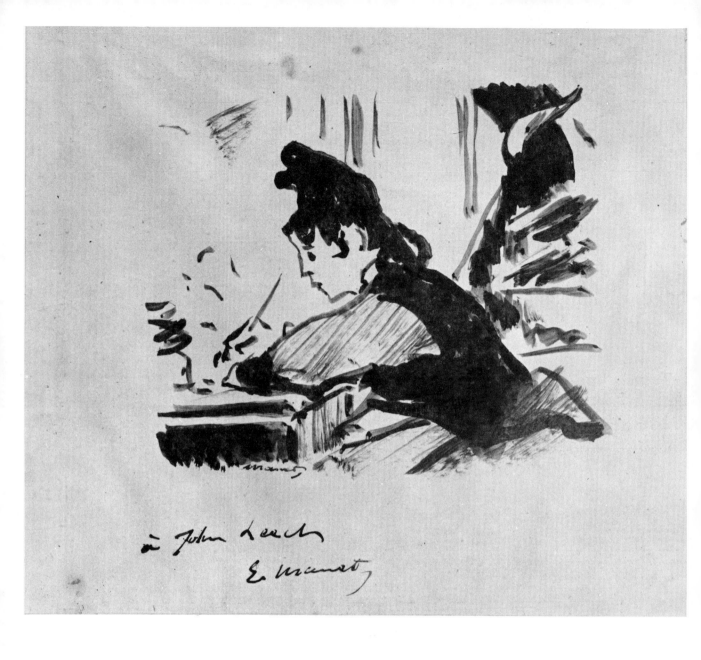

EDOUARD MANET
Woman Writing
Brush and black ink
5-9/16" x 6-1/4"
Courtesy of the Sterling and
Francine Clark Art Institute,
Williamstown, Massachusetts.

Like most artists, Manet spent hours studying the work of older masters: Velásquez, Hals, Giorgione, and Goya. Japanese prints — in which he was especially interested — had a profound influence on his work. This little drawing is characterized by a combination of both spontaneity and self-assurance. Each line, though brushed in very rapidly, seems perfect for the form or gesture which it describes. The drawing is organized around several opposing diagonal movements anchored to the page by a few horizontals and verticals. Like all good drawings, every aspect seems consistent throughout; the drawing is all from the same piece of cloth. Would a very detailed portrayal of the eye or hand have been in character with the rest of the drawing?

also describes the pose. The white page takes on added significance in this problem since there is such a dramatic contrast between its white surface and the black line, so make these white spaces just as interesting as the painted strokes.

Suggested Materials: 18 x 24 bond paper; one or two inch varnish brush; black tempera paint; container for water.

Time: Several hours, but return to this exercise often.

SMALL BRUSH GESTURES

Try some gesture drawings — using the same approach — with a #1 or #2 long-bristled camel or sable hair brush. Notice how the drawings change from being forceful, strong statements, to soft, flowing, rhythmic drawings.

HAND GESTURES

Your hands are an excellent motif for quick gesture drawings, just as they offered an endless variety of form for contour drawing. Use a variety of materials, starting with five second gesture drawings and gradually increasing the time to two or three minutes, then to five or ten minutes. Place ten or twenty of these drawings on a single page while you attempt to create an over-all composition.

Suggested Materials: 18 x 24 drawing paper; black chalk or compressed charcoal dipped in water occasionally while drawing.

Time: How long will it take you to do one hundred of these?

T. V. GESTURES

The television screen provides you with a continuous stream of people, places, and events which cry to be translated into gesture drawings. As you watch, hold a sketchbook and a pencil in your hands, and let the pencil swing at random in response to the various gestures and actions you observe on the screen. After a while, your hand should respond almost automatically to what you're seeing. The movement of your hand should become your natural response to the whole world of your experience. Incidentally, this activity will soothe a guilty conscience over spending too much time in front of the "big, bad box."

Although this isn't a gesture drawing, it is an interesting solution to my request to "do some drawings while watching television." Student drawing by Leslie Wasserberger. Photo, Uht.

Suggested Materials: Whatever is within your reach during the commercials; such as, a pencil and telephone pad.
Time: Depends upon the degree to which you are "hooked."

DOGS, CATS, AND KANGAROOS

Animals of all kinds are exceptionally fine subjects for gesture drawing. If you don't have a pet, you can probably borrow one for a few hours from your neighbor. Of course, if you're near a zoo or dog kennel, you'll have an endless variety of motifs for your gesture drawings. I often suggest to my students that they take a date to the zoo, thus combining their social life with the continuous pursuit of their professional goals. The problems in capturing the essential gesture of animals are the same as those encountered when you draw people or inanimate objects.

Suggested Materials: All that your date can carry! Burden your date with a fishing tackle box *loaded* with *all* your materials.
Time: As long as your date can stand, but at least two hours.

PAPER TOWELS

In a class one day, I was introducing gesture drawing using Conté crayon as a medium. Having a difficult time getting the students to "loosen up" and to create free-flowing, rhythmic gestures, I suggested they switch to large, one or two inch varnish brushes. Several students had only small brushes and they continued to draw in a tight, restrained manner. Determined to loosen them up, I suggested they use paper towels soaked in paint or India ink. The very nature of this material—that it tends to create masses rather than lines, and also that it's too wet to allow any resistance—forced them to "let go" with the materials and the motif.

I suggest paper towels to you as an excellent material for this purpose. Incidentally, have you tried a sponge or a tennis ball?

Suggested Materials: 18 x 24 bond paper; paper towels; ink or tempera.
Time: Hopefully, you're self-motivated by now and spend endless hours on all these problems.

This strong gesture drawing was created by working with both hands: a pencil in one hand and brush and ink in the other. 25 seconds. Student drawing by Geraldine Jond.

SALVATOR ROSA
The Temptation of Saint Anthony
The Metropolitan Museum of Art,
Rogers Fund, 1912.

The content of this baroque drawing is certainly unlike the idealized church paintings of the mannerists who preceded Rosa. His realism has an earthier quality about it which may reflect the fact that Rosa chose to live as an outcast or Bohemian artist. The principal rhythm of the composition creates a large *S* curve. Squint your eyes to see this movement and also to see the subtle dark and light structure which enhances it. The same value of the background tone is pulled into the principal figure to indicate light and shadow. The individual gesture drawings of the figures are remarkable but even more remarkable is the way he has treated the over-all form as one big gesture complimented by minor movements and directions. Note how Rosa moves you in and out of space through the opposing diagonals. At first glance it may seem as though there are a thousand extraneous lines in this drawing, but all of them are important.

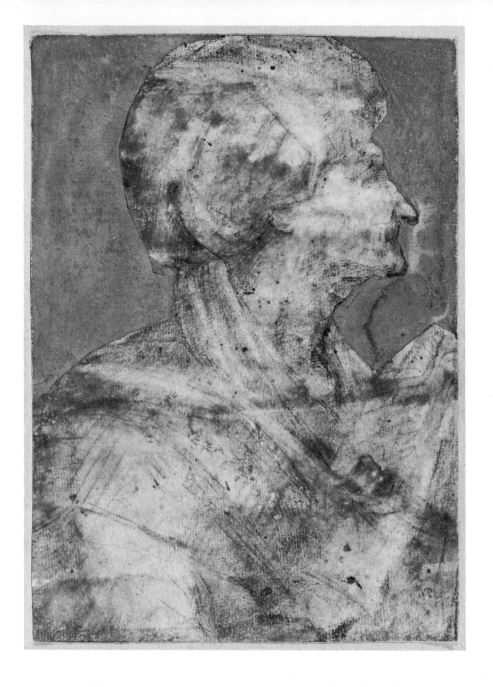

GIOVANNI BATTISTA ROSSO
Head of Old Woman
Black chalk on grayish paper,
heightened with white
7-7/8" x 5-11/16"
The Metropolitan Museum of Art,
Rogers Fund, 1962.

This work has an unusually contemporary look about it for several reasons. First, the fact that the figure has been cut out and pasted down relates it to collage; second, the unusual textural quality reminds one of the contemporary French painter, Jean Dubuffet. The hard edge of the outline is contrary to the slight amount of linear definition which occurs in the interior of the form. The beautiful profile of the face is given added importance by the addition of the white tone in the background. The light and dark modeling is rather arbitrary — it does not relate directly to the form, except in the head. There is a translucent quality which makes it seem as though the light is coming from *within* the form rather than being reflected from the surface.

5 *modeled drawing*

Essentially, there are two ways of defining form: by line or by juxtaposing two tones or values. Most paintings and drawings combine these two approaches, since the contrast generally helps to create a visually exciting statement. We will concentrate on one approach at a time, however. We've already dealt with the means of defining form by line, contour drawing. Modeled drawing, the method we'll study in this chapter, delineates form with tone — a range of values from light to dark.

PUSHING AND PULLING To begin, use a soft drawing tool, such as Conté, chalk, or charcoal. Since you delineate the form *not* by using a contour line, but by developing tones, a modeled drawing demands a different kind of thinking. Try to think of the page as a large piece of clay from which you develop a form by *pushing and pulling* (exerting varying degrees of pressure on your drawing tool). As you push and pull, the form emerges.

Like contour drawing, this kind of drawing continues to be primarily a tactile experience. You must believe that you are touching the form. As the form moves "back" you *push* on your drawing implement to push the form back. This causes the tone to darken and achieves a three dimensional effect. Don't confuse this kind of drawing with the problems of shadows and shading. Shadows depend on the way the light hits a particular form. Modeled drawing is only concerned with the form itself. A form which moves back into space is darkened regardless of the lighting situation.

If you're working with an instructor, he might help you by demonstrating a modeled drawing of a head. Using the side of a Conté crayon and starting with the bridge of the nose, he will "push" back to the cheeks and then push back further into the eye sockets and pull out to develop the forehead, and so forth. He might even have a piece of plasticene available to show that the same push and pull applies when you model with the clay. If you're not working with an instructor, try to experiment with pushing and pulling on your own.

Using the side of her chalk, the student pressed hard when the form moved back and eased up on the pressure as the form came forward. This creates the light and dark effect. Drawing by Carol Bruns. Photo, Goldberg.

In modeled drawing, begin in the middle of the form; push back to the edge, which will be soft, perhaps ragged. An occasional line may act as a foil to modeled tones. Drawing by Stephen Sugarman. Photo, Goldberg.

CONTROLLING THE TONES

Start from the middle of the form and work outward. The edge, which is never sharply defined (as it is in contour drawing), will not emerge until the drawing is practically finished. In the beginning, work very lightly — almost delicately. Reserve the darks until the very end; they are like a trump card you use when the drawing needs dark tones. Attempt to develop a wide range of tones, from the very lightest value to the most saturated black. This whole exercise is on a middle ground between contour drawing — building the whole from parts — and gesture drawing — building *from* the whole *to* the parts.

Start by drawing sustained poses — thirty minutes to an hour long — and gradually work faster, using five to ten minute poses. Don't make "finished" drawings, but concentrate on developing your perception of form. Realize all of the potentials of drawing and/or seeing so that eventually they will become as integral to you as the body-self. You will eventually be able to choose, select, eliminate, or combine elements in a drawing as automatically as you breathe.

All of these exercises will become means to achieving your end — a personal statement — arising from you just as naturally as you speak and gesture. There is no right and wrong; there is no one way; there is only your *self* and what you want to say. This means expressing what you must say with all the means at your disposal and with the deepest possible personal conviction.

**AN APPLE
OR THREE**

A cylindrical form—such as an apple—provides an excellent form for practicing modeled drawings. Try several drawings which accurately record the actual size of an apple and then try a drawing tremendously out of scale. Use an 18 x 24 sheet of charcoal paper and draw the apple to fill almost the entire page. This exercise should emphasize the crucial importance of scale in drawing and how this factor, in itself, can be an important expressive force. Try to use a very wide range of values, from very dark to very light, with six or seven steps between the two extremes.

Next, arrange three apples in such a way that two of them seem to "pull together" because they are close to each other. You're trying to create a grouping which has a variety of tensions. If I place three dots in this fashion •• • we tend to "read" or perceive them as two dots and one dot. Now you must model each form, inventing some tones in the *background* (or negative space) which will relate all three apples to the page and to each other in an interesting way, and placing all of them on the page to create a dynamic breakup of space. Perhaps you can create interest by drawing tones with a variety of texture. This depends on the rhythm and pressure you apply to your chalk. Don't try to finish one area and then move on to the next. Rather, develop the whole drawing simultaneously, since whatever you do in one area has a profound effect upon what happens to the form in the rest of the drawing.

Suggested Materials: 18 x 24 charcoal paper; compressed charcoal or a graphite stick.

Time: This problem could occupy the rest of your artistic career, but three or four hours at this time will suffice.

TRY A PORTRAIT

With the same approach you used drawing the apples, now create a self-portrait or a portrait of one of your friends. Generally, I discourage my students from

Combining contour drawing and modeled drawing in charcoal created this moving portrait of a Bowery derelict. The dark background tone was arbitrary and used for compositional purposes. Student drawing by James Thompson. Photo, Goldberg.

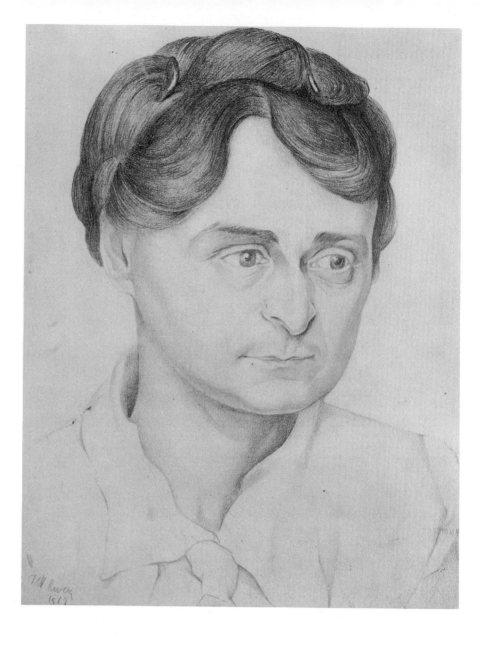

DIEGO RIVERA
Woman's Head
Pencil
Collection, Carl Zigrosser
Photographed by Philadelphia Museum of Art.

Despite the fact that the most exciting aspect of art in the twentieth century has been the development of abstract and non-objective art, artists continue to work in a realistic mode. This penetrating portrait is by the modern Mexican muralist, Diego Rivera. The subtle range of values from very dark to white is particularly interesting. Most beginning students lack both the ability to *see* this wide range and the technical ability to achieve it. Although the light coming from the upper left would actually cast a very large, dark shadow beneath the nose and neck, Rivera greatly modified the cast shadows to avoid distortions. Note also how he selected the major rhythms and forms in the hair to create a texture which *suggests* that every hair has been drawn. Study the features on this portrait very carefully to understand their structure better.

72

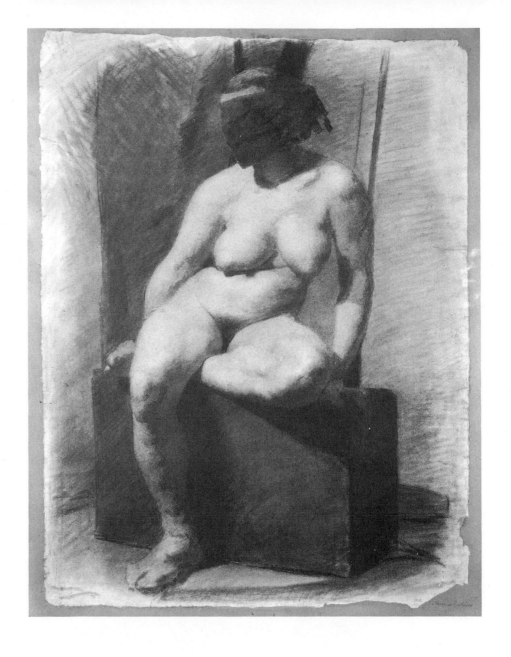

THOMAS EAKINS
Nude
Charcoal
Philadelphia Museum of Art
Photograph by A. J. Wyatt.

Such modesty! In Eakins' day, it was not considered proper to model nude and the models often wore masks to hide their identity. By contemporary standards the mask almost adds a surrealistic quality to the drawing, performing an aesthetic function at the same time. Its rectangularity and dark tone repeat the tone and shape of the box on which the model sits, while establishing an opposing movement into space. Eakins is a realist; but like all fine artists he picks and chooses as he sees fit. He merely *suggests* the toes, but he can't resist the shadow the breast casts on the arm, a shadow which actually causes a tremendous distortion. There are few Renaissance or Baroque masters who would have indicated this shadow with so much contrast. Notice how the movements in the figure are echoed in the surrounding space.

doing portraits of other people, since this situation has a way of making you feel that you have to draw a "good" portrait to please the sitter. As you develop the tones in the portrait, you'll notice that the head doesn't seem related to the background, because the background is still all white. You can arbitrarily place a few tones in the background which will help relate the head to the background.

You can even model hair if you disregard its linear qualities and search for large shapes and rhythms to model tonally. There may be a slight amount of "cheating" (remember these are exercises); for instance, the whites of the eyes are in back of the lids but since this light is important to the drawing you would put it in despite the approach to modeled drawing which has been described.

Suggested Materials: 18 x 24 charcoal paper; Conté crayon or compressed charcoal.

Time: A drawing this complex should take you at least two hours.

The student used a marking pen to create the dots in this study of drapery. Wherever the form pushes back, create many dots to make a dark tone; as the form pushes forward, use fewer dots. Drawing by Enid Glaser.

DRAPERY AND DOTS Since we've already explored drapery in linear terms, why not study drapery in tonal terms? A piece of white satin or other shiny fabric is especially suited to this exercise; try to have some very large folds, some medium folds, and some small areas which are more complex than the other folds. This initial arrangement will determine your final composition, so you should try several dozen alternatives before making a final decision. You are, in effect, "drawing" with cloth.

74

VINCENT van GOGH
Haystacks
Pen and ink
9-3/8" x 12"
Philadelphia Museum of Art
Photograph by A. J. Wyatt.

It might be interesting for you to compare this drawing with the drawing by Michaux on page 112. The improvisatory, spontaneous line quality relating to calligraphy is also apparent here, though line is used to define specific "things" in our environment. It would be well for you to study the truly incredible variety of textures that van Gogh achieves with a single implement, and how he contrasts these to achieve his form and simultaneously repeats them to unify the drawing. Notice how, while contrasting his textures, van Gogh develops implied diagonal lines which serve to move you from the foreground into and throughout the drawing. Diagonals suggest space even when they do not relate to mechanical perspective. This is also true of overlapping forms and diminishing detail.

75

Build up this drawing with dots of ink. You can easily make the dots with a round nib Speedball lettering pen and ink. Wherever the form pushes back, you simply create many dots to make a dark tone; as the form pushes forward, you use fewer dots. If you look at a newspaper photograph under a magnifying glass, you should understand the general idea without any difficulty.

Suggested Materials: 9 x 12 drawing paper; round nib lettering pen; India ink.
Time: One hour should get you started.

WHITE ON BLACK, GRAY TOO

Using a white Conté crayon and black paper demands that you reverse all your thinking in regard to a modeled drawing. Instead of pushing down on your chalk to create a dark tone you'll have to push down to create a *light* one! For example, you would have to push down with the white chalk to create the bridge of the nose. Since we are accustomed to reading black symbols and images as positive form, this switch causes a startling response in the viewer. Your subject or motif can be just about anything: a live model, a self-portrait, a branch of leaves, or a still life.

After doing several drawings with white on black, you might want to introduce some gray tones with your layout chalk.

This exercise can be further extended by working with *both* black and white chalk on a toned paper of middle value, say gray.

Suggested Materials: Black charcoal paper or construction paper; toned charcoal paper in earth colors; white Conté crayon or white pastel; layout chalk in a variety of warm and cool grays.
Time: Five or six hours would not be too long to spend on a problem this complex.

COMBINE LINE

For this drawing, ask a member of your family to sit quietly watching television. Begin the figure as a regular modeled drawing, keeping the tones relatively light until you have achieved the basic proportions and gesture of the pose. As you proceed, incorporate some linear, contour-like drawing on top of—or in relationship to—the dark and light tones. The tone and line should complement one another. You may want to use line in only a few places on the drawing, or you may prefer to use it throughout. Perhaps you can model the upper portion of the figure and define the lower portion with a contour line. The interplay of opposite qualities usually adds tension to a drawing.

Suggested Materials: 18 x 24 drawing paper and black lithographic crayon.
Time: About one or two hours.

PENCILS, HARD AND SOFT

In all these exercises (except the dot exercise) you've built up your dark and light tones by applying pressure to the side of your chalk. Now you should try creating your tones by changing your drawing material and using only the point —not the sides—of your pencil. Rather than varying the pressure to achieve darks, you change to a softer pencil. Start drawing with a 6H pencil, quickly lay-

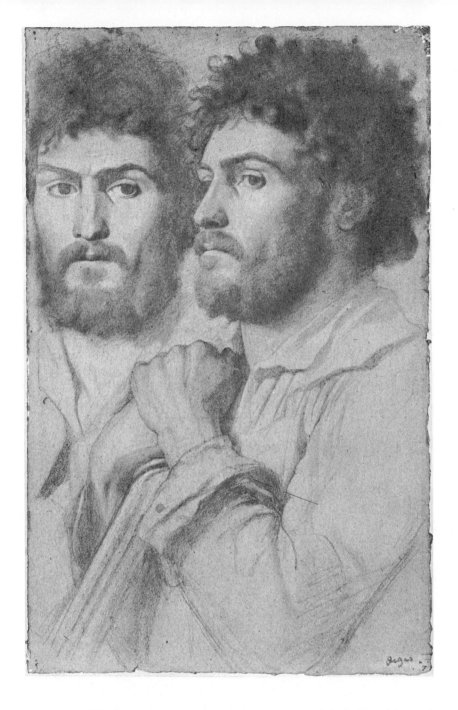

EDGAR DEGAS
Two Portrait Studies of a Man
*Pencil, with slight touches of white
heightening, on reddish-brown paper
17-5/8" x 11-1/4"
Courtesy, Sterling and Francine Clark Art
Institute, Williamstown, Massachusetts.*

In contrast to Degas' popular pastel drawings of the ballet, this work seems almost classical. Though he exhibited with the impressionists, Degas deplored the loose organization of their work. Tightly structured works of art are characterized by opposition of major and minor movements. What are the major and minor movements in this drawing? Is there a movement of light and dark tone in addition to the implied movement of shapes and lines? Master drawings often contrast highly finished areas (such as the subtle modeling of form in the heads) with other areas (such as the lower sleeve which almost looks like a scribble).

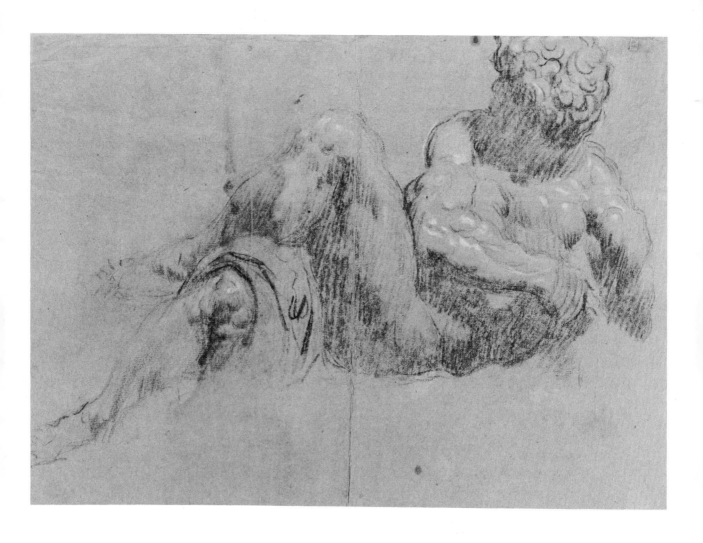

JACOPO TINTORETTO
Study after Michelangelo's Giorno
Black and white chalk on blue paper
13-3/4" x 19-7/8"
The Metropolitan Museum of Art,
Rogers Fund, 1954.

Tintoretto loved colossal nudes and was also fascinated by the effects of light, shadow, and atmosphere. How natural that he should study the work of masters who preceeded him. This drawing is a study of Michelangelo's sculpture, *Day*. Because so much can be learned from artists who preceeded you, I have included master drawings in this text; you should never miss an opportunity to study these and other drawings in their original state. This drawing also has a contemporary flavor about it; compare it with the Harold Altman drawing on page 98. Tintoretto's primary interest appears to have been in the major dark and light areas where the modeling is relatively lacking in detail but notice how an area such as the knee is drawn with tremendous refinement. Note how the spontaneous line of the drapery contrasts with the subtle drawing of the knee. The shadow on the side of the arm merges with the torso but is delineated with the softest touch of a line.

ing a very light tone in across the entire page. Let your hand and arm swing freely as you scribble in an area of tone. Next, using a 4H pencil, begin to darken areas where the form pushes back. Move on to a 2H, HB, 2B pencil, and so on until you're using the darkest pencil you have. At this point, your drawing should be nearly complete, with your darkest dark used sparingly to accent the passages you feel demand it. The range of values in this drawing should be considerable. Any objects might serve as subject matter for this drawing, but I suggest a simple two or three object still life to begin.

Suggested Materials: 18 x 24 drawing paper; complete range of pencils.
Time: Two or three hours.

This modeled drawing, using a dry brush and ink, was created from a 10 minute pose. Study the variety of textures which this student achieved with a single brush. Drawing by James Gormley. Photo, Waggaman.

DRY BRUSH AND SCULPTURAL FORM In this problem, the motif for your modeled drawing will be a sculpture. If you have access to original sculpture, or if you live near a museum or art gallery, you have an advantage. If you're not so fortunate, you'll have to use reproductions in art books, obtainable at your local library. The work of August Rodin, Henry Moore, Aristide Maillol, Alexander Archipenko, Jean Arp, Gaston Lachaise, and William Zorach are a few sculptors whose work would lend themselves well to this problem.

Create a modeled drawing of the sculptured form, using a dry brush technique. Dry brush is achieved by dipping a quarter inch or half inch bristle brush into India ink or black tempera and wiping the brush almost dry on a towel or rag

Practically all the vocabulary of cubism is contained in this little still life. Simultaneity or the viewing of an object from different positions in space — from the front, from above, from behind — and incorporating these aspects into one drawing, was the most radical innovation of the cubists. They seem to twist and bend objects to show what might be the most "readable" aspects of a given object. The basic shape of the siphon is shown in profile but the top is bent forward to show that it is a circular form. Planes are shaded or modeled from light to dark so that one side is clearly delineated and the other side becomes ambiguous or almost disappears. Forms are made transparent — you are able to see what happens behind a form. At times the shapes in the background seem more important than the objects themselves. Depth or a feeling of space is created through the use of receding diagonals. Lines, such as the diagonal in the background are picked up in the foreground. At one moment a tone appears to lie in one plane and the next moment, in another plane.

This drawing is much more than a realistic rendering of several objects. Sheeler is often grouped with a number of other artists who worked in a similar mode and who are sometimes referred to as the Precisionists or the Immaculates. Though at first their work appears to be almost photographic, a more careful analysis indicates that their work is, in fact, a compromise between realism and abstraction. Sheeler helps us to see familiar objects from a new point of view in the context of a highly intellectualized and carefully calculated arrangement of shapes, lines, directions, and tones. He creates a structural skeleton of interlocking horizontals, verticals, and diagonals; some of these are obvious at once, while others are more subtle. Note how the molding on the left is picked up in the crevice of the log in the foreground and how the right side of the log is in line with the edge of the wall in the background. Study the subtle modeling of the "not quite" vertical and "not quite" horizontal lines in the distant plane. The shadow of the light form on the floor, if continued, would connect with the point where the curve of the plate meets the log and also at the far left edge of the drawing where the wall meets the floor. These movements are called implied lines.

CHARLES SHEELER
Of Domestic Utility
Conté crayon
25" x 19-3/8"
The Museum of Modern Art, New York
Gift, Abby Aldrich Rockefeller.

81

before applying it to the page. You should test the brush each time on a scrap of paper to be sure you know the density of the tone you're about to achieve. You obtain darks by brushing back over an area again and again.

Suggested Materials: 18 x 24 drawing paper; quarter inch and half inch bristle brushes: India ink or black tempera; paper towels; reproductions of sculpture.
Time: At least an hour on each drawing.

ARBITRARY TONES Using a hard pencil (4H), begin a left handed contour drawing of a very complex still life. Since your left hand lacks the motor coordination of your right hand, you tend to distort and exaggerate forms in an expressive manner. This contour drawing will be the basis for the development of a modeled drawing in pencil.

Unlike the basic approach to modeled drawing (darkening a form as it moves back in space), the tones you develop in this drawing will be arbitrary inven-

Beginning with a very hard pencil, the student made a left handed contour of the still life and developed it into a modeled drawing using arbitrary lights and darks. Pencils ranging from very hard to very soft were used in the modeling. Drawing by Phyllis Goodwin. Photo, Uht.

Working with the entire range of pencils, this student spent about 15 hours gradually building up the tones in this drawing. Note the imaginative treatment of the strings in the tennis racket, not broken in reality. Drawing by Bettejane Zito. Photo, Goldberg.

tions on your part. Darken an area or let it remain light simply because it "feels" right to you. Try to develop a pattern of light and dark tones. A whole section of your drawing may function as a large area — even though it consists of many different objects — if the tonality which you apply to them is similar. In the Goodwin drawing, you can see how the teapot, the cloth, and the bottle "belong" together because they are all light in tone. Develop some areas which are very light, some which are very dark, and some in between. Where you want the form to be very important, develop strong contrasts of light against dark and dark against light.

This is not a rendering of the still life any longer, but a "form-invention," requiring a great deal of imagination and creativity on your part.

Suggested Materials: 18 x 24 drawing paper; complete range of pencils from hard to soft.
Time: You may very well spend from six to eight hours on a drawing as involved as this. It should be worth it.

MODELING WITH PEN AND INK

The subject matter for this exercise may be a posed figure or a simple still life. The problem is to make a modeled drawing using a thin pen line with India ink. This means obtaining tonal effects with a linear instrument similar to the drawings you did previously with pencil points. In this instance, you develop your dark tones by repeatedly going back over the same area. You might try several of these exercises, attempting in each instance to change the basic character of your pen strokes; one type of stroke might be very controlled with the neighboring strokes rather parallel; another type of stroke might be cross-hatched; and still another might be a very scribbly line.

Suggested Materials: 18 x 24 drawing paper; crowquill pen; India ink.
Time: Approximately an hour on each drawing.

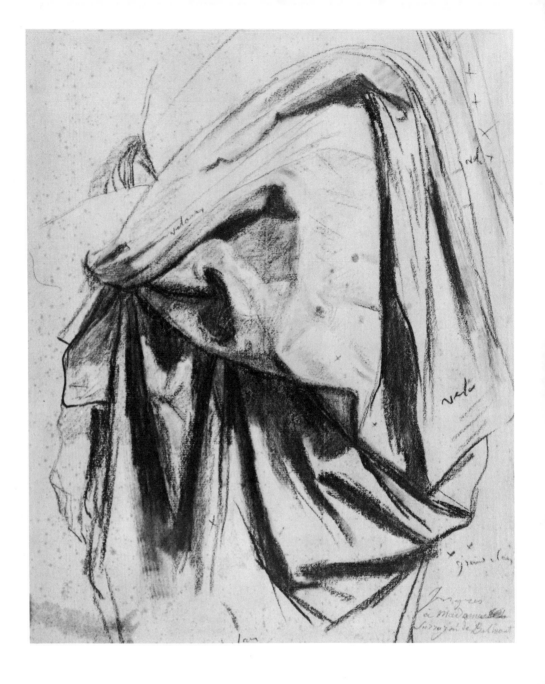

JEAN AUGUSTE DOMINIQUE INGRES
Study for Drapery
Black crayon
12" x 9-13/16"
The Metropolitan Museum of Art,
Rogers Fund, 1937.

Ingres was a pupil of Jacques Louis David and became the leader of the French Academy. This stunning drawing is almost the antithesis of the style which we normally associate with Ingres. He was a neo-classicist and noted for his hard, precise delineation of form in which modeling was rather suppressed. Noted as one of the greatest draftsmen of all time, his forms are generally rather cold and intellectual. In this drawing, the form is realized primarily through sharp dark and light modeling and the lines are soft and fuzzy. The drawing communicates a sense of warmth and near expressionistic frenzy when compared to most of his work or to the work of David. As a study for a painting, this drawing contains some color notes.

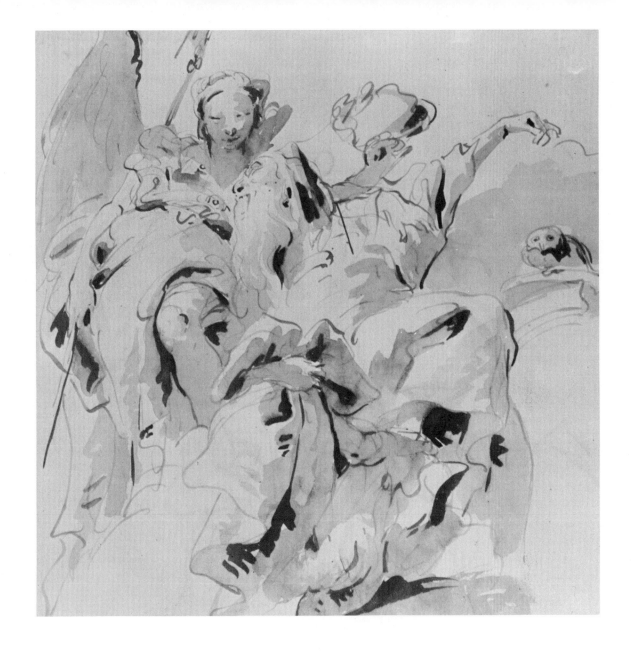

GIOVANNI BATTISTA TIEPOLO
Virtue Crowning Wisdom
Pen and wash with traces of black crayon
on white paper
The Metropolitan Museum of Art,
Rogers Fund, 1937.

This drawing almost seems charged with a dynamic and explosive energy. Everything contributes to the jumping movement but the dark accents are most instrumental; in fact, the accents are so contrasting that they nearly subordinate the forms to which they belong. The forms appear to be broken. It is so difficult to tell where one form begins and the next one ends that the individual figures are almost destroyed. The lines, tones, and dark accents create a form which is more than the sum of two figures. Many people find it nearly impossible to locate the second head in this drawing since it is so well integrated with the surrounding forms. Note the apparent speed with which the contour lines are drawn and the exaggeration in the gesture of the bodies. Do you see any relationship between this drawing and the Michaux on page 112?

JOHN PAUL JONES
Still Life
Charcoal
27-5/8" x 40"
The Museum of Modern Art, New York.

The primary aesthetic element in this powerful, semi-abstract still life is the dramatic contrast between the strong lights and darks. The bold horizontal movement of the light table plane in the near-center serves as an axis for the vertical activity above and below it. How does Jones relate the light tones of the table legs to the forms on top of the table? What means does he use to relate the objects to the background? Note how important the introduction of an occasional diagonal is in indicating space. The artist's interest is in the space occupied by and surrounding the objects rather than in the objects themselves. Though this is basically a tonal drawing, lines serve a very important function in the over-all composition. Why did Jones smudge some areas of this charcoal drawing and not others?

6 *modeled space*

The concept of modeled space is rather difficult to grasp, but a concept which is extremely important. In the previous modeled drawing exercises, you pushed form back into space by darkening the area which moved back. After developing some facility, you attempted to vary the texture of the tones to provide further interest and to "activate" — give life to — the drawing. In the final problem, you progressed to the point where the darks and lights did not necessarily follow the form; rather, they were arbitrary. You made whole areas of the drawing light or dark or middle-toned, or you contrasted sharp darks against sharp lights simply to create an interesting and visually dynamic page.

By now, you should realize that everything you draw on the page may help activate the form — should orchestrate the form — and that the quality of the tones and their relationships to one another must be interesting and alive in themselves, apart from their descriptive function. Until that point, your main attention was given to the object — the *positive form* — that you were drawing.

WHAT IS MODELED SPACE? When we talk of drawing modeled space, we mean that you are to *draw everything but the object itself*. Now you are going to make a modeled drawing consisting of light and dark tones interrupted occasionally by a line for accent or definition. But you're not going to draw the object itself. Rather, you're going to draw or model the nothingness which surrounds the object, the push and pull of the air or space. You're going to concentrate on the *negative space* or the *ground* surrounding the object. You're going to try to *invent* ways of describing what the space is doing, ways of rendering the tension which exists between these various "chunks" of space, and the relationship of this space to the objects which it envelopes.

Can you touch this space? It is ambiguous and demands a great deal of invention on the part of the artist to describe it through drawing. You must use your imagination and sensitivity to the relationships of line, tone, and texture to "say" what is happening to this space.

Using olack, white, and gray chalk, the student drew the space around the figure rather than the figure itself. Naturally, the figure does emerge. Drawing by Sharon Geher.

The student covered the entire paper with a middle gray tone. She indicated the space around the figure by erasing into the gray, adding black and white chalk and pencil. Note how a black and white drawing can seem to have "color." Drawing by Barbara Kramer.

NO RIGHT OR WRONG

Although there is no right or wrong way of indicating this space, this concept may be clarified if you consider the space in terms of the shape created between the objects; or if you think in terms of transparent planes, almost as though there were innumerable sheets of glass occupying all of the negative space, criss-crossing back and forth all around the objects. Or you might think of this space as empty volumes, such as the spatial volume inside an empty cup.

STRING UP THE MODEL

I use a model when I introduce the problem of modeled space to my class. I take a big ball of string and tie one end to the model and then proceed to wind the string around objects in the room, from wall to wall, back to the model, over to an easel, back to the model, down to the floor, back to the model, over to a stool, back to the model, and so forth. When the whole room is criss-crossed with string, we can see how the string defines big transparent planes and volumes of nothingness which center on the model. This helps my class see what may be happening to the space and to interpret this activity through their drawing.

A ROOM FULL OF ICE

Furthermore, you might understand the nature of this negative space if you imagined that the room in which you are sitting was suddenly filled with water. Then imagine the water freezing into ice. Now remove all of the solid objects from the room and draw the remaining ice.

88

This is like the molds used to cast ceramic sculpture, an example of negative space made positive. The empty space in the mold is actually the figure.

A FOUR-LEGGED STOOL

Imagine a four-legged stool. The space surrounded by the four legs, the seat, and the floor is a rather clearly defined space and, therefore, not too difficult to draw. However, the space which exists above the seat and to the sides of the stool is much more ambiguous, since only one plane of the stool is defining it. To draw this space demands a great deal more on your part. In fact, you must invent an arbitrary means of activating this space through various tones, textures, and lines.

Imagine the space extending to all sides of the room in which the stool is located and imagine that the four sides of your page represent the sides of the room. This will help you draw the space with your chalk.

NO SILHOUETTES

Invariably, when students first attempt this problem, they end up drawing the model in silhouette because they model only the space extending *outward* from the sides of the model. Then I have to make it clear to them that space exists *between* them and the model and that they'll have to indicate this space. Furthermore, there's space between the model's chin and her chest; how can you indicate it? There's space from her torso to her thighs; how can you indicate it? Naturally, what happens as this space is "worked" is that the positive form or figurative elements emerge.

This figurative element, however, is not simply a dark image stuck on a white page, but rather, a drawing which grows out of, and is intimately related to, all the space in the drawing. This exercise forces you to see and understand that the entire area of the page is essential to your drawing; that you should not start with a left eye-brow and hope that everything you do subsequently will "fit;"

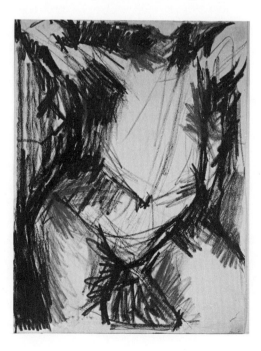

Drawing the "nothing" which surrounds the figure often results in a silhouette; this is avoided if you realize that space also exists between you and the model. This exercise forces you to compose the entire page. Student drawing by Helene Basist. Photo, Goldberg.

that the whole drawing has to grow as a piece. The left hand corner of your page is just as important to the total form as a left eye-brow, perhaps even more important. You're trying to develop an awareness of the total space surrounding whatever object you're drawing, and you're also learning to be aware of the total page on which you are drawing the object.

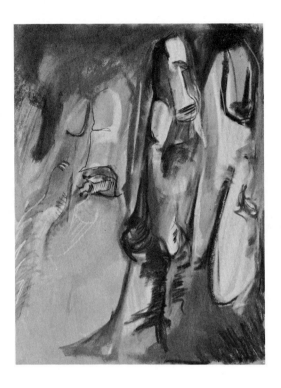

This is a modeled space exercise using hands as the point of departure. What devices has the student used in this colored chalk drawing to create an intimate marriage between the hands and the background space? Drawing by Martha Lesser.

OLD MASTERS DID IT

Look at tonal-linear drawings by Rembrandt or Rubens to see how — regardless of the subject — they made a "good" drawing by "activating" and integrating the total space within which they were working. Because these masters were so involved in the *total* space of the drawing, the drawings remain "good" even when they're turned upside down.

Essentially, we've been talking about a "marriage" of figure and ground which you can achieve in several ways. Cézanne is an excellent artist for you to study for this principle, especially in his use of "sliding planes," that is, a plane not clearly delineated on all sides. Cézanne obtains this effect by allowing a portion of the plane to remain open so that the plane adjacent to it is related through this space. One might ask whether this particular space exists on the forward or the back plane. The fact is, it exists on both planes and seems to be shifting back and forth. In artistic terms this is called *equivocal space*, something of an optical illusion.

RELATING SUBJECT TO BACKGROUND

Sheer tonal similarities also tend to relate figure and ground elements; darks in the figure and darks in the background will naturally relate because of their *similarity*. Similar tones relate even more if they are in immediate *proximity* to

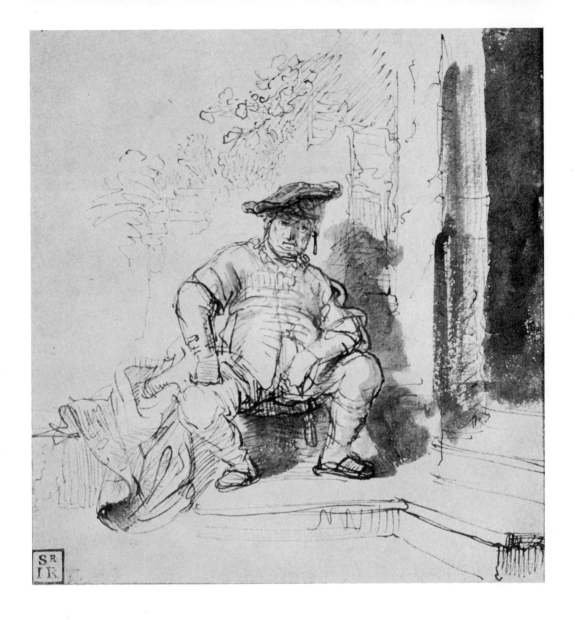

REMBRANDT HARMENSZ van RYN
Man Seated on Step
and wash with bistre, heightened with white
5-3/4" x 5-7/16"
The Metropolitan Museum of Art,
Bequest of Mrs. H. O. Havemeyer, 1929
The H. O. Havemeyer Collection.

Gesture drawing and quick contour drawing — as well as the concept of modeled space — are all evident in this beautiful little drawing. The line seems to have the freedom which most people have when they are involved in handwriting; despite this apparent freedom, you should note the degree of Rembrandt's control as when he changes the weight of the line, making it light on the light side and dark on the shadow side. The dark washes in the background help to indicate space because of the way they seem to imply a vertical movement away from the central figure. He achieves an incredible variety of textures with both his pen strokes and the washes. Note how he has used his darks to accentuate the weight of the man sitting and how he changes the directions of his shaded strokes to define further the manner in which each particular plane moves into and out of space.

FERNAND LEGER
Study for Mother and Child
Pencil
12" x 15-1/2"
A. E. Gallatin Collection,
Philadelphia Museum of Art.

The great French cubist painter, Leger, had a tendency to imbue all forms, including the human figure, with machine-like precision. This is certainly a legitimate response to the de-humanizing characteristics of twentieth century technology. This is an extremely "tight" composition, the parts fitting together like a jig-saw puzzle. The repetitive horizontals and verticals produce an almost architural over-all structure. Leger's handling of space is particularly interesting. He juxtaposes flat forms — the vase and lamp — which have no indication of perspective, with the two containers in the center background, which, since we look into them, must "read" as being far below eye level. This creates a spatial contradiction. Next to the three dimensional, almost sculptural modeling of the figures, he places a flat pattern of diamond shapes. In front of the whole composition — running from top to bottom — Leger draws a decorative panel which moves into space as a result of receding diagonals. Note how the hair of the mother is tangent with the vertical line running through the composition and belonging to the window panes in the background. This is an excellent example of equivocal space.

each other, separated by only a barely discernable "break." More often than not this subtle quality is even more "meaningful" if it is contrasted with a sharp break in tonalities somewhere else in the drawing — dark against dark, and then, dark against light or vice versa! Finally, another way to relate figure and ground, is by drawing lines and/or tones which move from the figure into the ground defining two different forms (equivocal space). You can study this phenomenon in the Leger drawing.

A PILE OF CHAIRS Collect a group of three, four, or five chairs and pile them up so that some are resting on their sides, some upside-down, and others stacked on top of one another. This arrangement provides an excellent motif for seeing the negative space surrounding an object. The spaces between the various parts of the chairs are rather clearly defined; you can see big volumes and planes of empty space moving into, through, about, and around the positive form of the chairs. This is what you must attempt to draw.

Use Conté crayon and try to develop a wide variety of tone, texture, and line. Try to make a drawing which is exciting in itself and also relates to the space of "chairness."

Suggested Materials: 18 x 24 drawing paper; black Conté crayon.
 Time: At least an hour. Put in as much time as the drawing demands.

MODEL THE SPACE Students who have difficulty in modeling negative space often are helped by
WITH COLLAGE portraying this space with collage elements. A collage is composed of various pieces of cut and torn paper or cloth pasted down to create (or to find) form. For this problem, limit yourself to black, white, and gray papers in a variety of textures. Numerous gray tones can be found in portions of photographs cut from magazines.

The tangibility of collage elements frequently simplifies the problem. When you tear out a big hunk of paper and paste it down — in the background — it is "real." With the first big shape of paper you paste down, you destroy the flat surface of the picture plane — you indicate at least two planes existing in space. Start with relatively big shapes, covering the whole page quite quickly, gradually working in smaller shapes of various tones which will begin to describe both the space around the figure and the figure itself. The image will not be an "accurate" representation of the figure, but rather a spatial suggestion of it; edges and contours may or may not be clearly defined; they may even run into the surrounding space.

You might argue that this is not "drawing." Remember, these are exercises designed to broaden your concepts and that hopefully you will eventually be able to apply — or reject — them.

Suggested Materials: 18 x 24 piece of scrap cardboard; white glue such as *Elmer's;* scissors; variety of collage materials.
 Time: Several hours on each collage.

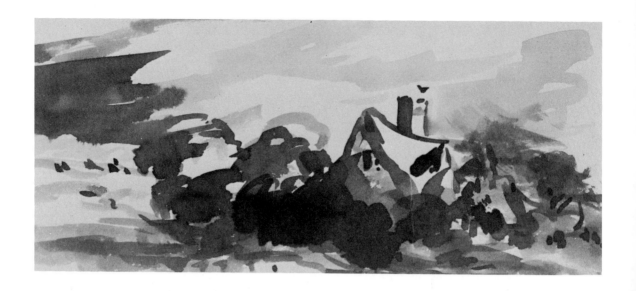

JOHN CONSTABLE
Country Cottage Amid Trees
Sepia wash
2-3/4" x 6-1/8"
Philadelphia Museum of Art
Photograph by A. J. Wyatt.

Wow! How could I find a better drawing to illustrate the marriage necessary between materials, form, subject, and content? This is not so much a cottage as it is a few dozen brush strokes! Can one exist without the other? Where do the clouds end and the foliage begin? Notice the difference in the *character* of the shapes created by the brush. Why didn't this *old master* make a distinct break between the clouds and the foliage? How did he create a transition between them? Though the shapes are very spontaneous, Constable had complete control of them. Why is it "looser" than his "finished" paintings? What *is* the difference between this drawing and an abstract-expressionist drawing or painting of the 1960's? One certainly does not have to work large to produce quality. How does it relate to the Michaux on page 112? How does he achieve emphasis, rhythm, and balance? Notice the attention he gives to the dark and light organization. How is weight of tone related to balance?

94

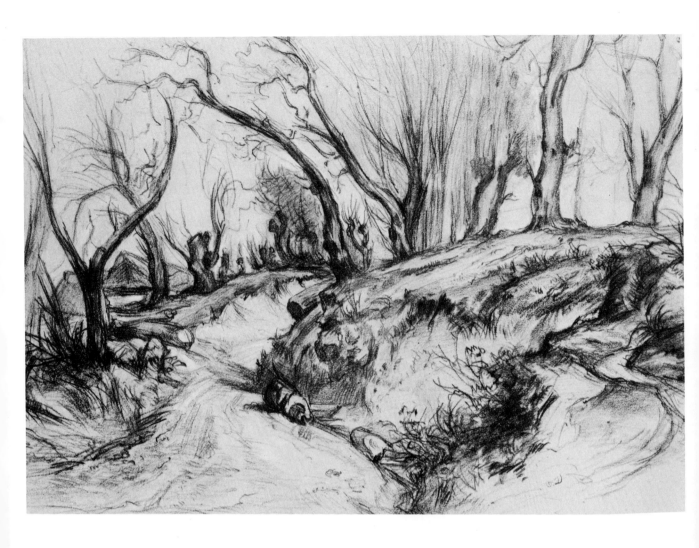

EUGENE DELACROIX
Winter Landscape
Black and white chalk on buff paper
10-3/8" x 15-1/16"
Courtesy of the Sterling and
Francine Clark Art Institute,
Williamstown, Massachusetts.

Delacroix was a Romantic who revolted against the tenets of neo-classicism. His work is characterized by almost frantic rhythms and robust painterliness as opposed to the rather static composition and linear forms of the neo-classicists. There is seldom a definite, hard edge in his work. His open forms and sketchy lines seem to imbue his work with energy, excitement, and action. This drawing looks as though the forms were created almost simultaneously as his chalk leaped from one area to the next, making a mark here, a tone there, a change of rhythm here, a scribbled line there. This fantastic variety of tones and textures provides the work with a great deal of color, despite the fact that it is black and white. Study the relationship of the trees to one another as well as the shape of the negative spaces existing between them.

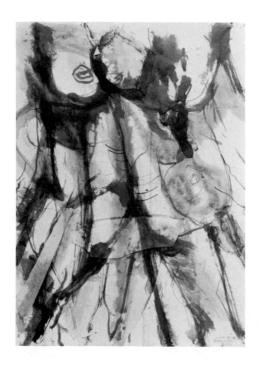

The student pasted down torn paper to model the space in this drawing of a figure in continuous motion. She then used brown ink to indicate other planes and various aspects of the moving anatomy. Drawing by Marianne Glick. Photo, Waggaman.

COMBINE DRAWING AND COLLAGE

For this exercise, use another arrangement of piled up chairs for a motif. Define the negative space with collage elements just as you did in the previous problem. When the larger shapes (planes of space) begin to relate or "work together," further enrich and define the various forms with linear or tonal drawing. Try to make the collage and drawn elements of your work mutually interdependent. Use any of your drawing materials, pen and ink, pencil, graphite stick, charcoal — but try to select a material which seems indispensably appropriate to the emerging form. You might need several drawing materials.

Suggested Materials: 18 x 24 piece of scrap cardboard; a variety of collage materials; white glue such as *Elmer's* (which dries transparent); scissors; all of your drawing implements.

Time: As long as it takes to create a dynamic image; one which you might hang in your living room!

"FEEL YOUR WAY" TO THE STREET!

Draw a street scene: "Feel your way" into the negative space and let your chalk respond to the large volumes of air surrounding you. As you respond, your chalk will model the space. As you develop a variety of large tones, gradually begin to "feel your way" into the smaller details of the environment. At this point, don't hesitate to use a linear quality if the drawing seems to beg for it. Try to create a greater variety of texture within your tones by freely rubbing into some of them with an errraser.

Suggested Materials: 18 x 24 drawing paper; black, white, and gray chalk; eraser.
Time: An hour or so.

96

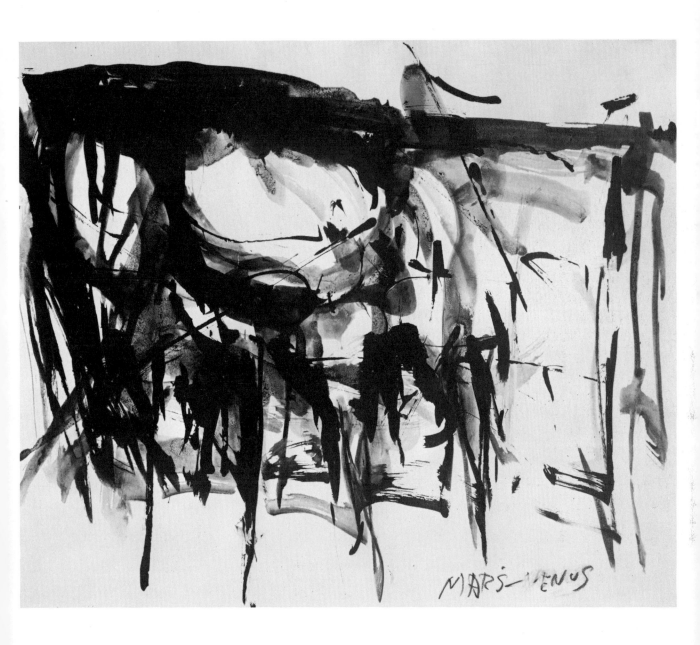

REUBEN NAKIAN
Study for Mars and Venus
Wash, brush and ink
14" x 16-7/8"
The Museum of Modern Art, New York
Charles Egan in memory of J. B. Neumann.

This calligraphic drawing is actually a study for one of Nakian's monumental sculptures. One is not able to identify any particular portion of the figures, because the drawing describes the *space* of figures rather than the literal delineation of specific forms. Here the quality and gesture of brush strokes and their relation to one another is of more importance than the figure's "left eye-brow." Despite the spontaneous quality of this drawing, there is a strong horizontal — vertical organization and a good balance between light and dark areas. In what ways does the organization of this drawing relate to the drawing by Juan Gris on page 80? This is an excellent example of modeled space, described in the text.

97

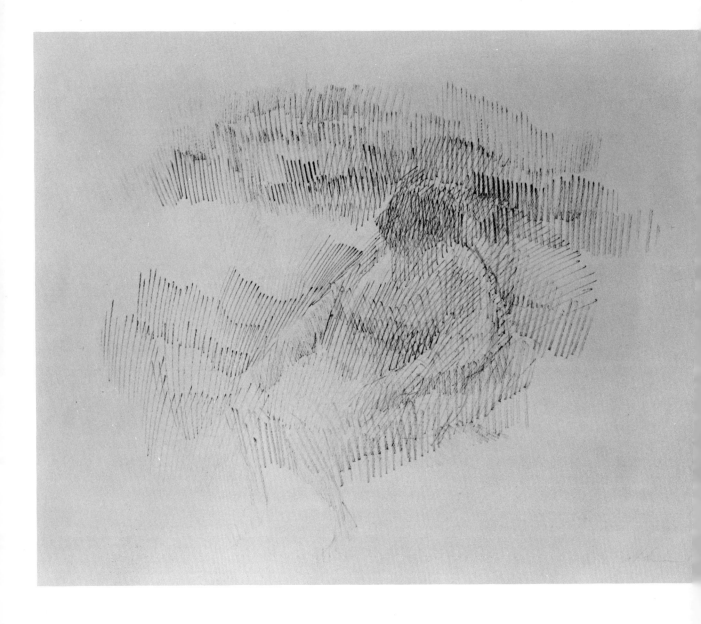

HAROLD ALTMAN
Matriarch
Crayon drawing
16-1/2" x 20"
Philadelphia Museum of Art
Photograph by A. J. Wyatt.

Perhaps the charm of this drawing is the fact that it all looks so easy to accomplish. A few parallel lines here and a few there and presto a figure emerges. But what marvelous control of tonality! Notice how the emergent form depends as much on the various directions of the strokes as on the changes from light to dark. Note also the varied character Altman achieves in what at first glance may appear to be a rather repetitious quality in the crayon strokes. The space which is achieved through overlapping planes is reminiscent of Cézanne's technique. If you squint at the drawing, you'll see how he has organized relatively dark areas, areas of middle tone, and areas of light to give the drawing a sense of structure.

The student selected a bridge as the motif for this exercise in modeled drawing. The student created textures by wetting the chalk and by erasing into chalk tones. Drawing by Rene Conrad. Photo, Waggaman.

LANDSCAPE AND WET CHALK

On a bright, sunny day take your drawing materials out to the park or countryside for this exercise. Create a modeled drawing of the landscape, making use of "sliding planes" to create the effect of equivocal space, that is, space which seems to exist simultaneously on two planes. Before attempting this exercise, you really ought to study the drawings, paintings, and watercolors of Cézanne, the master of equivocal space.

Use chalk—as you've done in previous exercises—but dip the material into water before applying it to the page. This will create an effect which can't be obtained any other way—exploit this technique for your own personal ends. You might also try moistening portions of the paper before working on it.

Suggested Materials: 18 x 24 drawing paper; chalk.
Time: Try several five or ten minute drawings and then one for a more sustained time.

MODEL WITH WASHES

For this exercise, set up a relatively complex still life around a large, leafy house plant. To model the nothingness of the space surrounding the objects you'll use India ink washes for building the tones. This medium requires a little experimentation. Light tones are made by mixing a great deal of water with just a drop of India ink; dark tones by adding more ink.

You should test each tone on a scrap of paper before putting it on your drawing to be sure you know exactly what you're working with. You can obtain interesting effects by letting two adjacent tones run together or by drawing into a wet tone with pen and ink. Tones may be built up transparently, like innumerable sheets of glass — one on top of another — but you must let each tone or wash dry before applying subsequent layers if you want to achieve this effect. You might combine a dry brushed tone with very wet tones. This is a difficult but fascinating problem and one which you'll want to adapt to other subjects.

Suggested Materials: 18 x 24 watercolor paper (white drawing paper may be substituted); brushes; India ink; palette; pens.

Time: Three or four hours, including time for some preliminary experimentation.

THE SKY'S THE LIMIT

Almost all the subjects, techniques, and problems suggested in preceding chapters may be adapted to drawing modeled space. You can interpret any subject with any drawing material or technique individually or in combination. Don't limit yourself to the few problems suggested in this or any other chapter. Imagine all possibilities lying at your fingertips and begin to reach for them. To complete a single problem, such as a self-portrait, in terms of modeled space does not mean an end to the problem. You could work on this single problem the rest of your life and not begin to touch upon all of the possibilities it offers for creating expressive form.

Hopefully, the suggestions I've made will be a mere beginning for you. Now that you've taken your first flight, try to reach for the moon and beyond.

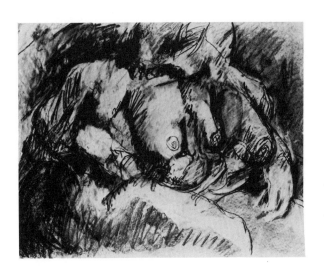

A modeled space exercise on a toned paper forces you to create white or light areas. Usually the white areas are the portions of the paper which remain. Contrary to the effect of the drawing, the model was stationary. Student drawing by Kathleen Mittlesdorf.

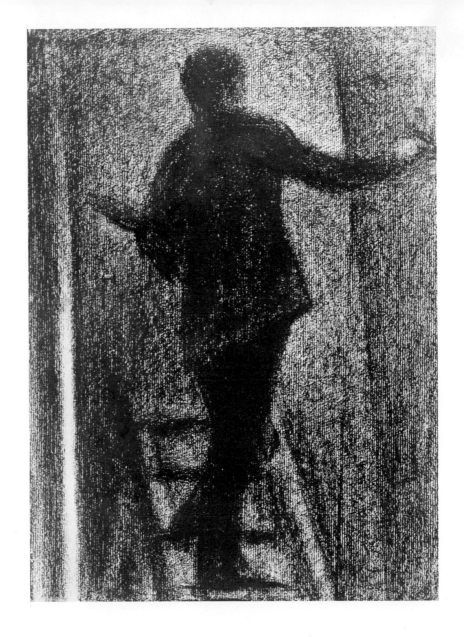

GEORGES SEURAT
The Artist's Studio
Black Conté crayon
12-1/8" x 9"
Philadelphia Museum of Art.

Isn't it strange that we usually think of drawings as primarily linear in nature? Of course this is a result of our own conditioning and shortcomings. Form may be defined by line, by color meeting color, or by the contrasting juxtaposition of tones. Seurat chooses the latter method, since it seems to "fit" his aesthetic bent. I don't particularly care for this drawing! I'll readily admit that my indifference to it is my weakness rather than Seurat's, perhaps I don't "read" it correctly, and as I get to know it better I may respond differently. We don't have to like everything, even when a master's name is attached to it. There are many Seurat drawings that I nearly "flip" over...why not this one? Note how Seurat slows down the rapid movement of the curved arm out of the drawing by opposing it with the subtle diagonal in the background. This subtle diagonal also serves to echo the strong white diagonal on the other side.

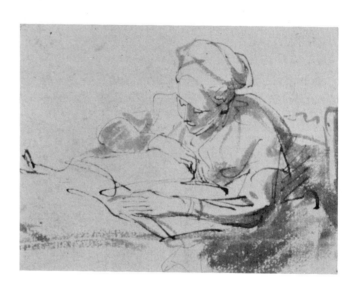

REMBRANDT HARMENSZ van RYN
Woman Reading
Pen and bistre, washed
2-5/8" x 3-7/16"
The Metropolitan Museum of Art,
Rogers Fund, 1926.

This tiny drawing is proof that quality does not always depend on size. I prefer this little work to many of Rembrandt's paintings. Less studied than his major works, these little drawings appeal to our contemporary vision. The sparsity of line amounts to a kind of shorthand and yet everything about the pose is related — even the reflected light along the jawbone. The parallel strokes shading the back overlap into the background and then become a contour definition of the skirt which creates a particularly interesting passage. Note also the contrast between a line drawn with a pen and a line drawn with a brush; how does Rembrandt relate these two aspects of the drawing?

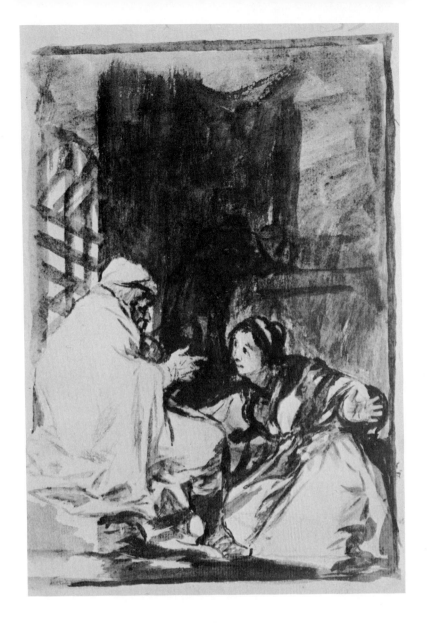

FRANCISCO GOYA
Woman Kneeling Before an Old Man
Wash drawing in sepia
8-1/16" x 5-5/8"
The Metropolitan Museum of Art,
Dick Fund, 1935.

Goya is a master in organizing his work. Note the sharp dark and light contrasts and how the dark in the foreground moves left, behind the leg, up into the woman's dress, and back to the large, dark rectangle where a group of barely discernable figures is located. The diagonal movement of the darks in the woman's dress is picked up in an implied line which continues into the background. The pointing finger sets up an implied horizontal which echos the horizontals in the background and foreground. These horizontals are balanced by a number of vertical movements; the dark verticals in the background are picked up, or continued right down through the figures to the foreground plane. Note how Goya has left a little white spot in back of the old man's face. Also notice the amount of definition he gives to the stark white robe with just a few brush strokes.

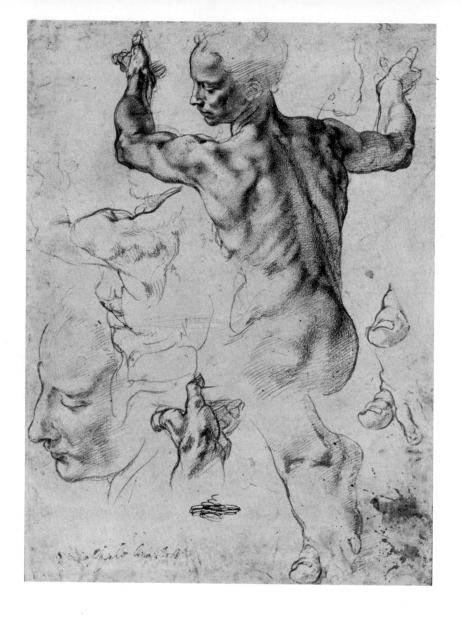

This beautiful page by Michelangelo is interesting to us for several reasons. First, we're almost overwhelmed by his sheer mastery for delineating form with line and tone and the way he combines both of them. The nuances of light and dark, as he models every subtle variation of form in the back, is a real *tour de force*. Study the variation in the texture and degree of "finish" in the modeling, ranging from an almost scribbled tone to precise modeling. There are eight separate studies on this page, ranging from a tentative gesture to an almost photographic rendering of form; yet the whole page — including both the positive and negative space — seems almost predestined. Michelangelo couldn't help composing, even on a page of studies. Note how the weight of the line changes to indicate the manner in which light is hitting the various forms. This drawing has a great deal of color despite the fact that it is monochromatic. What accounts for this?

MICHELANGELO
Studies for the Libyan Sibyl
Red chalk, face of sheet
The Metropolitan Museum of Art,
Purchase, 1924, Joseph Pulitzer Bequest.

104

7 *memory drawing*

Until now, you've been drawing directly from a motif, either a figure or an object, but now you should also try to draw from memory.

Generally, students have more difficulty drawing from memory than they do using the other methods discussed in this book. This is because they lack knowledge about whatever they are drawing. For example, few people are familiar enough with the form and detail of an alligator to make a very convincing drawing of one, although most people could suggest the *general* character of an alligator quite easily. The problem of memory drawing, therefore, is one of visual recall. You must develop the ability to reestablish in your mind's eye what you have previously observed.

INABILITY TO OBSERVE

When I introduce memory drawing to my classes, I do it in this way: I place a simple form, such as a bottle, on the still life stand *before* the class assembles. Then, after the class discusses their homework assignment, and without making any reference to the bottle, I go to the front of the room and cover the bottle. I ask the class to draw, as accurately as possible, the bottle which was on the stand. Catching them unawares this way tests their observation. As a rule, the students not only are unable to recall the shape, proportions, texture, color, and detail of the bottle, but they are unaware that the bottle had been there at all.

This exercise demonstrates—somewhat dramatically—that our ability to observe and remember needs to be developed. The following exercises may sharpen those abilities.

OBSERVE AND REMEMBER

Place a bottle before you and observe it intently for about one minute, noting as many significant characteristics as possible. Remove the bottle from view and try once again to record as much about it as you possibly can.

Charcoal is excellent for this exercise since you can erase easily and correct the drawing as you search for the shape and proportions of the original bottle.

After finishing your drawing, study the bottle again and compare it with your memory drawing. Check its proportions, the relationship of height to width, the distance above or below eye-level, the thickness of the bottle, and any other significant details which characterize this particular bottle. In order to correct the discrepancy between what you see and what you remember, it helps to correct the shape and proportions of your drawing with a red pencil.

Suggested Materials: 18 x 24 charcoal paper; charcoal; eraser; red pencil.
 Time: Depends on how *much* you can recall and your ability to record it.

OBSERVE THE WHOLE

Place a different bottle on the stand and observe it for about a minute just as you did in the previous exercise. This time, when you remove the bottle, use a different "attack." First create a gesture drawing in Conté crayon to indicate the general mass and proportions of the bottle's shape. Try to recall the whole bottle all at once and use your gesture drawing to respond to the total form. Two or three minutes should be sufficient for this exercise.

After you've done this, use a soft pencil to create a *contour drawing* of the bottle on another page, indicating as much detail as you can recall. Use the first gesture drawing as a reference for the over-all shape and proportions of the bottle. After you've finished the contour drawing, return the bottle to the stand and compare your drawing, marking the major discrepancies in red pencil.

Suggested Materials: 18 x 24 drawing paper; Conté crayon; 4B pencil; red pencil.
 Time: Twenty minutes, but could be repeated indefinitely with different objects.

SEVERAL OBJECTS AND THEIR RELATIONSHIPS

After several attempts at making memory drawings of relatively simple forms, you should repeat the exercise using two or three bottles instead of only one. This problem is more complex, not only because you must recall each object individually, but you must also recall the spatial *relationship* (the negative space which exists between them) of each object to one another.

Suggested Materials: 18 x 24 drawing paper; charcoal; 4B pencil; red pencil.
 Time: As much as you need; repeat with other objects.

COMPLEX FORMS

As your ability to draw these simple forms increases, you're ready to move on to more complex forms. After a one minute observation, try drawing a teapot, a leaf, a branch, a shoe, an opened book, a key, your big toe, your foot — all from memory. In fact, try drawing everything!

Suggested Materials: Same as above.
 Time: How much do you have?

RECALL MAJOR FORMS

Drapery is an excellent motif for memory drawing, since the variations in the individual folds are generally quite subtle. This means searching for the one

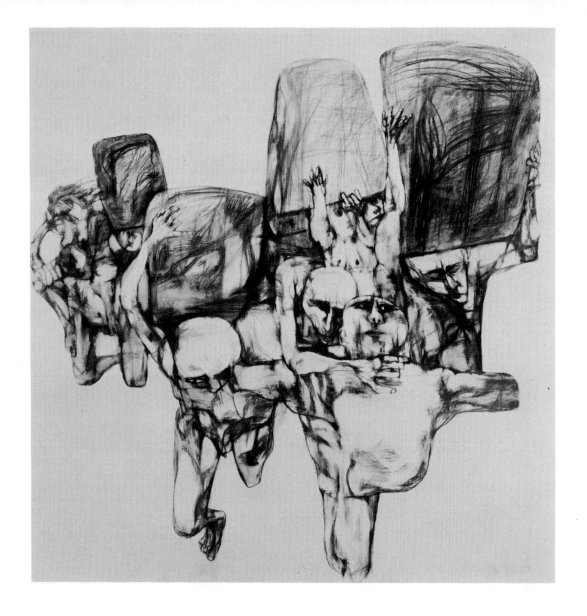

In classical mythology Sisyphus was sent to hell, condemned to roll a gigantic stone to the top of a hill. The stone constantly fell back as soon as Sisyphus reached the summit. Because of their universality, myths continue to inspire many modern artists. The futility and frustration of Sisyphus is intensified by the over-all form Landau created rather than the specific image of a man with a heavy stone on his back. The weight of the large upper forms (stones) pressing on the complex lower forms (distorted and foreshortened figures) is nearly unbearable. The extraordinarily large scale of this drawing is a crucial factor in communicating its content. Note how Landau relates the stones to the figures through tones and lines which run from one form into the other, obscuring a definite edge. Due to this equivocation of space, it would be nearly impossible to cut out the stones with a scissor, since they are intimately related to their adjoining forms. In the hands of an artist with less talent, this drawing could easily slide into the realm of illustration.

JACOB LANDAU
Sisyphus
Charcoal
Philadelphia Museum of Art
Photograph by A. J. Wyatt.

107

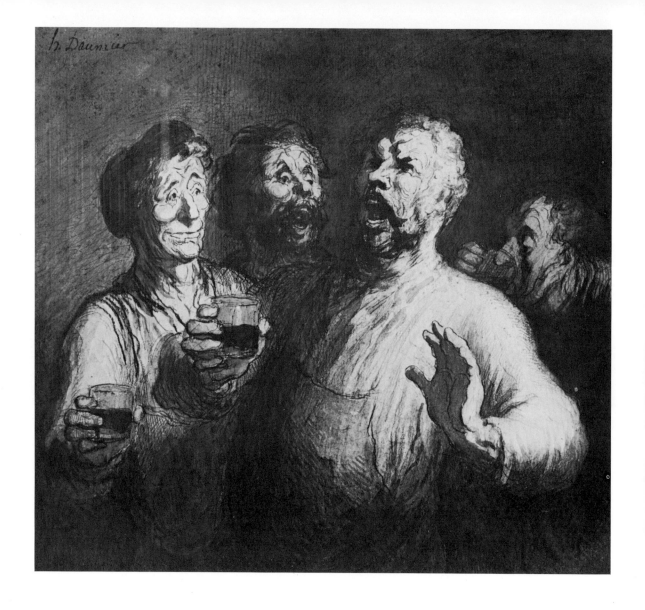

HONORE DAUMIER
The Song
Black chalk, pen and black ink,
gray wash, and watercolor
9-5/16" x 10-7/16"
Courtesy of the Sterling and
Francine Clark Art Institute,
Williamstown, Massachusetts.

Perhaps the finest draftsman of the nineteenth century, Daumier earned his living as a political cartoonist. His drawings were often such biting commentaries on his time that they even got him into trouble with the government. Daumier — who studied Michelangelo and Rembrandt — was a master of *chiaroscuro* (the technique or organizing a work of art through the use of strong lights and darks). Daumier's light and dark contrasts provide a drama of form invention supported by his confident line. He was especially adept at capturing the most significant gesture of his subjects even though his drawings were made from memory! The upraised hand in this drawing is particularly interesting because of Daumier's severe economy of line and the sharp contrasting of two flat tones. Why is the hand on the extreme left almost lost in the shadows rather than treated with equal contrast? Note the large triangle formed by the two hands on the left, the head of the foreground figure, and his upper and lower arm. Are there other implied triangles in this drawing?

or two major forms or rhythms within the motif. Once again, it will probably help if you start with a gesture drawing. From this, using a Conté crayon or black chalk, develop a modeled drawing. After you've done a modeled drawing, do a contour drawing without any modeling.

Suggested Materials: 18 x 24 charcoal paper; Conté crayon or black chalk; eraser.
Time: Two hours.

I asked the students to draw the entrance to their houses from memory with as many details as possible. After finishing this exercise, I told them to return to the spot and see how much they really did remember. Drawing by Kathleen Forance.

THE OBVIOUS Here is another excellent exercise in memory drawing. Try to recall and draw an event, scene, or object with which you come into contact daily, but which you take practically for granted. For instance, draw the entrance to your house or apartment, or the contents of your medicine chest, or dressing table. Naturally, after you finish drawing you should go to the actual motif to see how much you really remembered...or forgot! Try the same drawing again a few days later to see if there are significant forms which you now recall.

Suggested Materials: 18 x 24 charcoal paper; charcoal pencils; eraser.
Time: Thirty minutes to an hour; repeat often.

PROJECTED SLIDES AND PHOTOGRAPHS Projecting color Kodachrome slides provides an excellent means of developing memory drawings. If you do not have access to slides and a projector, you can use regular photographs cut from magazines. I handle this exercise in much the same way as the others. Show the slide for a minute or two, turn off the projector, draw as much as you can remember.

Using slides and photographs has the advantage of putting the whole visual

world at your fingertips. The subjects can become exceedingly complex and thus challenge your memory. Because most slides are complex, I usually let my students take a "refresher" look after they've drawn for about ten minutes.

Suggested Materials: 18 x 24 charcoal paper; charcoal; eraser; Kodachrome slides; projector.
Time: Hours and hours.

These are memory drawings of figures from Kodachrome slides. The image is projected on the screen for 1 minute and I give the students about 2 minutes to draw the pose from memory. Drawing by Kathleen Forance.

Using Kodachrome slides of the posed figure, 3 different poses were projected in sequence for about 1 minute each and then the students had 20 minutes to draw the sequence from memory. Drawing by Kathleen Forance.

RECALL A SEQUENCE A very difficult problem—one which my students generally enjoy because of its challenge—involves drawing a *sequence* of subjects from memory. This can be accomplished by using either a model, projected slides, or photographs. For instance, I show three different slides of a posed model for about one minute each and then have my students draw all three poses from memory. This exercise also works very well with an actual model. However, since models also have short memories, they usually find it difficult to resume the exact pose they had held. This makes it awkward for students who want to check their accuracy. For this reason, slides might be preferable here.

Suggested Materials: 18 x 24 charcoal paper; charcoal or Conté; eraser.
Time: Several hours. Repeat.

110

MEMORY DRAWING FROM LIFE

In spite of the difficulties involved in resuming the pose, using a live model has many advantages for memory drawing. At the end of a twenty minute pose, I ask the model to strike another pose for about a minute and then I have her break the pose. I then ask the class to draw the pose, a request received in dismay, for the students realize how little they had observed. Neglecting to observe usually happens only the first time.

During the next memory drawing exercise, I ask the students to assume the same pose that the model has taken. When they strike the pose, I ask them to "feel" how their skeleton is arranged and how the various muscles in their body are pulling and pushing. Then I tell them to draw the pose from memory. The results are usually much better in this exercise, since their memory extends *beyond* their eyes, into and throughout their whole body-self.

Here is another way to use a live model as an extension of this exercise. Draw from memory, not the pose which you observed from your particular position, but rather the pose as you might have seen it from another viewpoint: from the opposite side of the model; or from directly above the model; or from an ant's eye view of the model.

MEMORY OR IMAGINATION?

Still another exercise which I use frequently while the model is taking a break, is to tell a story and ask the class to illustrate all aspects of the story with quick gesture and contour drawings. For example, illustrate the following: A boy is walking down Main Street; he walks through a door; sits at a counter of a luncheonette; he sits next to an old lady and a young girl; the attendant is stout and jolly.

The problem in this exercise is not only to characterize all the figures and actions, but to "fit" the drawings into the page and relate them to one another at the same time.

Another aspect of this technique is having someone describe a *single* event and to draw it. For example, a feeble old washerwoman is about to carry a heavy laundrybasket up a flight of stairs; she bends down to pick up the basket. You must draw the moment when her frail body senses the full weight of the load.

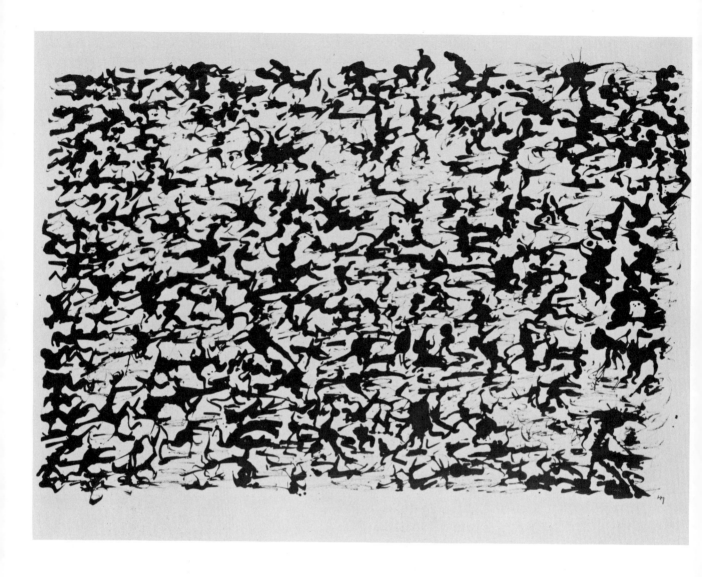

The relationship between drawing and calligraphy is made very obvious in this work. This drawing reflects an attitude and philosophy distinctly contrasted to what has traditionally been considered the basic tenets of "good" composition in art. This work is spontaneous and improvisatory, unlike work which is carefully structured in relationship to the picture plane and the format. A parallel might be drawn between a carefully choreographed dance and the movements of a dancer as he freely improvises. Though you may read into the marks in the same way as you respond to an ink-blot, the marks actually exist for themselves as compulsive, automatic gestures. They are as "real" as a drawing of an apple. The space is not closed or contained, but rather open and infinite. You might try to respond here as you do to the leaping flames of an open fire — both compel attention and involvement.

8 automatic drawing

The title of this chapter seems to *imply* drawings which are machine-like, or machine-made, produced by the thousands on a super computer. On the contrary, automatic drawing is a type of drawing which is produced from your subjective response to purely visual phenomena, phenomena which have no outward or conscious relationship to actual objects or "real" experience.

EMPATHY
The concept of empathy is most relevant to this problem of automatic drawing. Empathy is your ability to put yourself into another person's place, to completely identify with another human being. You are capable of identifying not only with animate, but inanimate objects as well. How does it feel to be a piece of paper, to be written upon, to be crumpled up and tossed into a waste basket?

It's also possible to identify with purely artistic elements and their inter-relationships. How does a line "feel" next to a dark mass? Next to a light mass? How does it feel if the line is criss-crossed by several other lines? How does it feel if the line is red rather than blue? If it is a dotted line or a wiggly line? In this sense, empathy refers to the energy you use when you respond to the purely visual elements comprising a work of art, or a work of art in progress.

THE DRAWING ITSELF
Until now you have often been asked to identify with a particular motif, image, or subject. Now you're going to identify with nothing other than the drawing itself, not the line describing the contour of an arm, but line itself and all of its expressive and form possibilities. You'll no longer identify with the tone which describes the subtle curve of a cheekbone, but tone for its own sake. You'll identify with texture simply because human beings *respond* to texture, not the implied texture describing the tactile quality of a piece of drapery.

HOW TO BEGIN
No doubt the first question you'll ask is: If I'm not going to be drawing any*thing*, where and how do I begin? You begin by beginning! Don't begin with any pre-

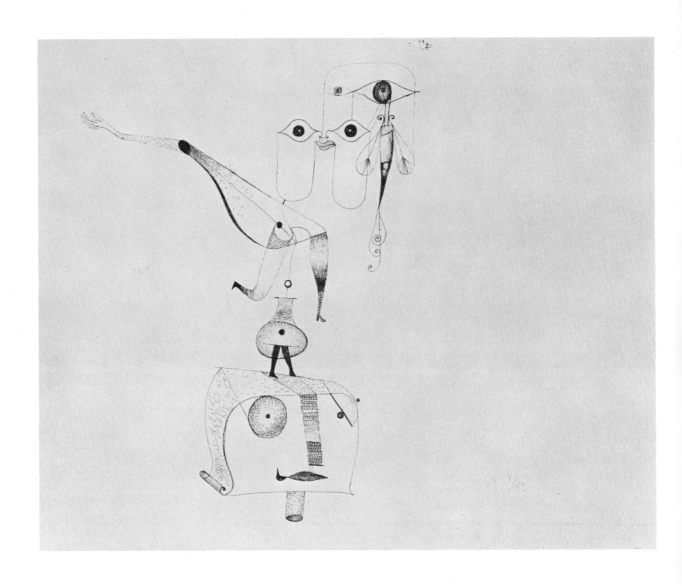

PAUL KLEE
A Balance-Capriccio
Pen and ink
9" x 12-1/8"
The Museum of Modern Art, New York
A. Conger Goodyear Fund.

In terms of sheer inventiveness, Paul Klee towers over the artists of the modern era. Klee did not approach his work with pre-conceived notions as to what the outcome of his efforts might be; in fact he speaks of "an *active* line on a walk, moving freely, without goal. A walk for a walk's sake." On still another occasion, he suggests that "all true creation is a thing born out of nothing." Klee was not interested in rendering what was visible; he wanted to render visible that which was invisible. A compulsive worker, in 1939 knowing that he did not have long to live, Klee painted two thousand works!

114

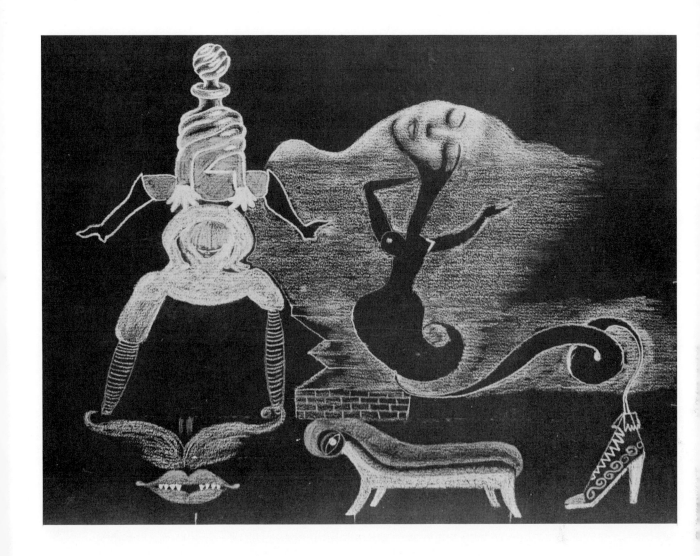

VALENTINE HUGO,
ANDRE BRETON,
TRISTAN TZARA,
and GRETA KNUTSON
Cadavres Exquis (Landscape)
Red, yellow, and white chalk on black paper
9-1/2" x 12-1/2"
The Museum of Modern Art, New York.

Exquisite Corpse is the name given by the surrealist painters to a "game of paper-folding [this particular drawing does not appear to have been folded], which involves the composition of phrases or drawings by several people, without any of the participants having any idea of the preceding contribution or contributions." In these drawings, there is a juxtaposition of forms and objects suggesting a disorientation which the imagination of a single individual could never achieve. It is an interesting way to achieve forms which are almost beyond one's imaginative capacity. A variation that I often try when a class gets in the "doldrums" is simply to let everyone work on a drawing for five minutes and then pass it around the room letting each successive person draw on it for five additional minutes. The previous work acts like a trigger to stimulate tired or "hung up" imaginations.

Using a ball point pen, a 7 year old boy created this automatic drawing. He started with the big, flowing line and then scribbled in each of the areas. Note the incredible variety in the major forms which at first appear to be very similar. Drawing by Khym Kaupelis.

conceived notion of what the finished product will look like. When you "doodle" on a pad, while talking on the telephone, the image just grows and develops in an almost unconscious manner; the final form of these doodles depends on one factor: the length of your conversation. Your approach to automatic drawing should be quite similar to that of your telephone doodles: intuitive, subjective, and only semi-conscious.

Have all of your drawing materials at hand and, in the beginning, work relatively large if you can (approximately 24 x 36"). Pick up a material — pencil, charcoal, brush and ink, or whatever — and proceed to let the material act on the space before you. Make a mark, any mark — curved, straight, scribbly, tight, loose — and then react to *it*.

Look at the mark, "feel" the mark, and let it "tell you" what the next response should be. It's like the old psychological game of free association: if I say grass, you're very apt to say "green." Respond as rapidly as that to your page and the marks on it. Is the previous mark or gesture demanding a change of material? Is it "begging" for a deep dark tone to "support" it? Should you switch from brush and ink to charcoal, which can be smudged with your hand or eraser? Remember, don't *impose* a form on the work, but let it grow naturally out of itself. The growth of this form is like an embryo, which grows, changes and develops from moment to moment until it's ready to be born — a unique entity, a new, living, breathing, pulsating form.

A STAGE FOR ACTION

You might want to consider your page a gigantic stage for a group of dancers improvising movements, rhythms, positions, and gestures. Your dancers are your drawing materials, potentially capable of achieving a variety of effects. Is the dance slow, smooth, and flowing? Or is it fast and staccato? Are there variations on a theme? Do the movements have color? Are there solo actions? What is the pattern of the whole group moving together? Is there opposition to this movement? Does all of the action take place at center stage? Are some of the dancers more animated than others? Is there a continuity and a feeling of unity to the dance?

116

Can your page be a stage for a drama? How will it be different from the dance? Can your pencils create a tragedy? How must your chalk move in a comedy? In a musical comedy?

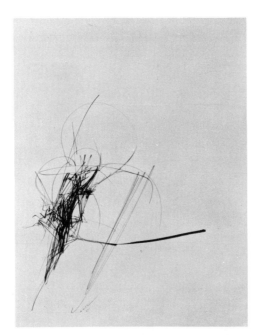

(Left) Begin an automatic drawing by beginning. After the first mark is down there is something to which you can react. What additional lines, shapes, or tones, is the initial mark "begging" for? Student drawing by Marilyn Motz.

(Below Left) The student tore up some unsuccessful wash drawings and reassembled them in a collage fashion to create this exciting and well-composed drawing. Drawing by Nancy Dresner. Photo, Waggaman.

(Below Right) If some spots, textures, lines, and areas of white tempera paint are allowed to dry and then the board is completely covered with India ink, startling effects can be obtained by washing the whole thing under a running faucet. These effects can be the springboard for further developing the work as an automatic drawing. Student drawing by Virginia Heffernan. Photo, Waggaman.

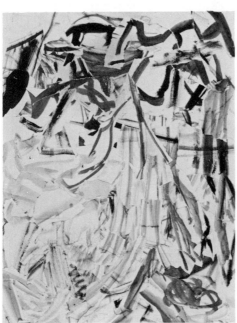
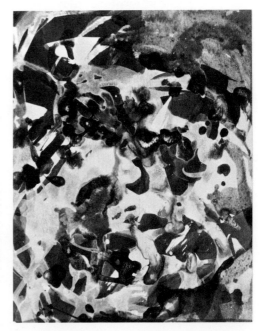

ON YOUR OWN! The very nature of this exercise negates the possibility of suggesting definite problems to be solved or subjects to be explored. Unlike preceding chapters, all I can do is suggest a few variations in your materials.

Try an automatic drawing with a single material, such as a pencil or a ball

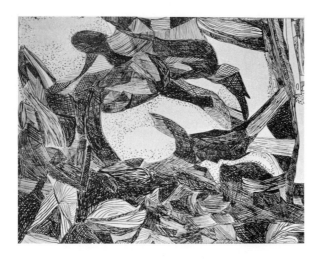

When the student started this automatic drawing, it resembled the kind of doodling one is apt to do while talking on the telephone. She then elaborated it, exploring the textural possibilities of pen and ink. Drawing by Helaine Seigal. Photo, Goldberg.

point pen. What will you do with a broad array of colors? Can you create an automatic drawing combined with collage materials? Try this exercise with black and white tempera and all of the intermediate grays but without paint brushes; try to paint with anything you can find. What can you do with a four inch house-painter's brush on an 18 x 24 sheet of drawing paper? How will your responses change if you switch from an 18 x 24 sheet of paper to one about 48 x 72? How will you react to an unusual format, say a sheet of paper 6" wide by 48" long? Can you make a drawing with a fine crowquill pen on a 4 by 5 foot page? What kind of form will develop if you use only your hands and fingers dipped in paint?

By now I shouldn't really have to suggest any materials to you. You should realize that the problems to be solved, as well as the content and the subject matter of your work, can't be imposed on you, because the answers rest within yourself. Through continued hard work and passionate involvement with drawing, they can be released.

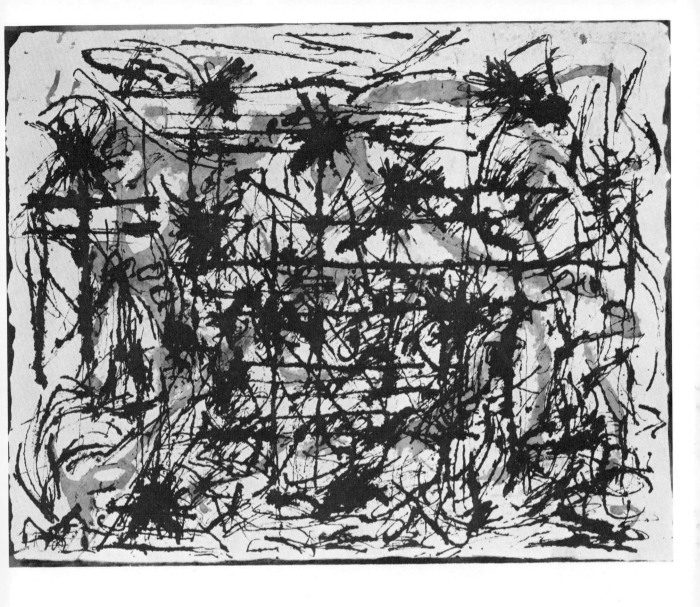

JACKSON POLLOCK
Drawing
Brush and black and red ink
15-3/4" x 20-1/2"
The Museum of Modern Art, New York
Gift, Mr. and Mrs. Ira Haupt.

Much influenced by the automatism of André Masson (see page 122), Jackson Pollock developed a form of painting which came to be known as "action painting." The page is an arena in which to act and the drawing or painting is a visible trace of those actions. The violent movement and energy of Pollock's work demands attention in a way which is similar to the leaping flames of a roaring fire. His work, rather than being contained within the format, seems to explode out of it, expanding outward in all directions; his work seems to reach out and envelop the viewer. "I have no fears about making changes, destroying the image, etc., because the painting has a life of its own. I try to let it come through. It is only when I lose contact with the painting that the result is a mess. Otherwise there is pure harmony, an easy give and take, and the painting comes out well."
— Jackson Pollock

JEAN ARP
Composition
India ink and wash, torn paper
11-1/2" x 12-3/4"
A. E. Gallatin Collection,
Philadelphia Museum of Art.

The name of Jean Arp has almost become synonymous with free-form shapes. Here Arp has made one drawing, torn it up, and re-arranged the shapes to create still another form. The similar character of the painted shapes in each torn section creates a unity which is somewhat "jarred" by the way they just miss flowing from piece to piece. The torn edges — which could not be achieved by any other means — contrast interestingly with the smooth edges of the painted forms. Because the light and dark areas of this composition are near-ly equal, it's difficult to discern between figure and ground or pos-itive and negative space. At one moment the black looks positive and at the next the light tone looks positive. This phenomenon is referred to as equivocal space or figure-ground interchange.

WASSILY KANDINSKY
Study
Pen and ink
9" x 13-1/4"
The Museum of Modern Art, New York.

Kandinsky is credited with creating the first non-objective painting: a painting with no motif; a painting which is its own reason for being. Comparing painting to music, Kandinsky argues that form and color can express emotions in a way similar to musical sounds. The spontaneous quality of his work is, in reality, quite carefully calculated and this calculation separates Kandinsky from the dada painters who attempted to achieve completely automatic responses. The lines and tones in this drawing suggest drama, energy, tension, and movement; there is no intention to describe specific objects. Kandinsky's work has had a profound effect upon the art of the present time, especially on those painters variously known as abstract-expressionists, action painters, or members of the New York School.

La naissance des oiseaux.

ANDRE MASSON
Birth of Birds
Ink
16-1/2" x 12-3/8"
The Museum of Modern Art, New York.

Mistrusting "artistic" motifs, such as apples or guitars, Masson revolted — along with the other surrealists — against the "thinking" mind and worked in a quasi-automatic manner. In this trance-like state, there was practically no element of calculation in his work. This particular drawing may be less automatic than most of his work, since here he creates a double image — the bird-like forms obviously also create a female figure. Masson loved Oriental calligraphy and the variety of lines in this drawing and the rhythms which they create reflect this interest.

122

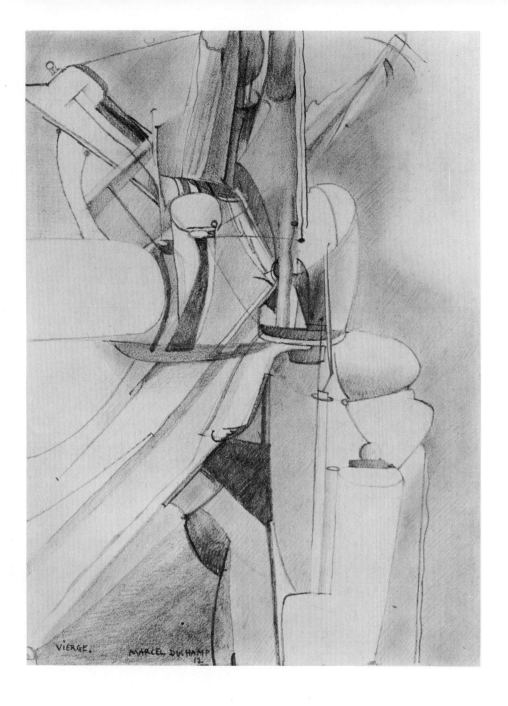

MARCEL DUCHAMP
Virgin
Pencil
13-1/4" x 9-3/4"
Philadelphia Museum of Art,
Photograph by A. J. Wyatt.

Duchamp executed this drawing when cubism was only a few years old and Kandinsky's first totally non-objective painting had been created only two years previously. The relationships of tone and shape in this work are both complex and beautiful. Note especially the heavily accented areas and how they seem to "sing out" in contrast to the broad light areas. Notice also how distinctly delineated shapes become larger wholes when there is a similarity in their tone. This is particularly apparent in the large white area on the left and the dark area in the upper center. Why did he repeat the circular form over and over again? Why did he vary its size?

PETER PAUL RUBENS
Battle Scene
Pen, brown ink, brown wash,
heightened with cream-colored gouache,
on brown paper
23-1/2" x 14-5/8"
The Metropolitan Museum of Art,
Gustavus A. Pfeiffer Fund, 1964.

Everything in this drawing seems to be intertwined in an orgy of perpetual motion. The form is overwhelming and seems to pull you into it, but doesn't let you focus for long on any single aspect because the scintillating lights and darks appear to jump into and out of space. The absence of a horizon contributes to this over-all effect and also to the rather shallow space. Note how he defines form at one moment with a line, at another with a tone, and at still other times he uses a combination of these two means. The composition depends upon a highly complex arrangement of opposing diagonals with nothing parallel to the sides of the paper. Compare this drawing to the Salvator Rosa on page 61, which is roughly from the same period.

9 drawing from projected images: a classroom technique

Drawing a variety of subjects from Kodachrome slides can be a most rewarding activity. This technique develops confidence in your ability to "attack" any motif as a subject for drawing; to "loosen up," to develop a rapport between motif, self, medium, and drawing, and to draw many subjects in a short time.

Although the procedures suggested in this section are most appropriate to a classroom situation, the enterprising student, working alone, should be able to adapt the suggestions to his particular situation. Basically, all the student needs is a 2" x 2" slide projector and some Kodachrome slides.

EMPATHY AGAIN

We have already discussed *empathy*—the ability of a person to identify with another person. Many people believe that the ability of an artist to empathize is the crux of achieving significance in his work.

We also agreed that it's possible to empathize with inanimate objects: how does it feel to be a cup? To have hot coffee poured into you? To be sipped from? How does it feel to be a particular mountain or tree; is it different in the summer from the fall? How does an artist's total self respond to a motif of huge boulders as opposed to grass waving in the wind?

HOW TO PROCEED

Proceed with this exercise by reacting almost instantaneously to the projected image. Feel your way into the image, move throughout the image. Believe that you *are* the image and that the reaction of your hand grasping the drawing tool— a physical extension of your self—manifests your total reaction. The mark on the paper *is* your experience.

For example, viewing a slide showing fruits and vegetables, compare your reaction to a head of green cabbage as opposed to a plastic bag of carrots or an over-ripe tomato. As you empathetically move through the forms, your chalk simultaneously moves about on your newsprint pad leaving a trace of your experience in the form of a line or tone. What kind of line or tone best suits this

particular experience? Can your chalk move through and around carrots in the same way as it moves through and around cabbage? How *must* your use of the material change? What does it *demand* of you? Play your material as though it were a Stradivarius violin — how many "notes" are possible? How many "beats?"

In the beginning, the slides should be shown very rapidly — from ten to thirty seconds long — as you respond to the entire image in the limited time. Unfortunately, this exercise means you will need another person to change the slides while you draw. Perhaps you can enlist the aid of another person interested in drawing who would take turns with you running the projector.

Since you may feel self-conscious about creating a "good" drawing and since this is primarily an exercise, you might even place one drawing right on top of another on the same sheet. The sheet is going to be thrown away anyway. After many of these, you might return to one drawing per page. After you repeat this exercise many times, your inhibitions and hesitance will begin to disappear and you'll literally *plunge* into each drawing, no matter what the subject. You've begun to develop the ability and confidence to draw anything!

Suggested Materials: 18 x 24 newsprint paper; chalk; pencils; charcoal; projector; slides.
Time: Several hours.

These variations on a curve are the student's initial, almost immediate reaction to a projected image of wrecked automobiles lined up in a junkyard. Through this technique, students discover that no subject is beyond their grasp. Drawing by Carolyn Brock. Photo, Waggaman.

This student used Conté Crayon, sepia ink, and a marking pen in this 2 minute response to a projected image of fishing boats. This is a visual trace of the student's involvement with the motif. Drawing by Sheila Bernstein.

126

EMPATHY, FORM, AND STRUCTURE	Eventually, you should realize that you identify not simply with the *subject* of the slide but, *more importantly,* to its *form* and *structure.* You respond to the space, the dark and light pattern, the color, texture, and form. Realizing this is the real aesthetic content of the experience and, hopefully, of the drawing.

Gradually, the time for each slide may be increased and you can simply delve deeper into the experience, refining and looking for subtleties, while maintaining your basic attitude and approach with a sense of confidence and forthrightness.

FORM AND MEDIA	After you've "loosened up" — as a result of the above exercises — you'll find that the variations in approach, media, and concepts are almost limitless. If you're working in a class, your instructor will no doubt introduce variations appropriate to the situation.

What happens when you change media? Notice how different the form appears when you work with a pencil (a resistant, linear material) after having worked with chalk, a non-resistant, tonal material. Try using a large brush with ink or black paint. Combine materials. Try brushing clear water over parts of a chalk drawing and then draw back into it with a twig dipped in ink. Whatever material you use, be sure to create a "marriage" between the created form and the material. You not only see the motif, but you also "see" it *through* and in *relation* to the particular material you have in your hand.

> *Suggested Materials:* 18 x 24 bond paper; brush; ink; chalk; pencil; twig; and anything else you can think of.
> *Time:* One or two hours.

INTUITION AND INTELLECT	In the beginning, your approach is intuitive, subjective, emanating for the most part from the intestinal tract rather than from the intellect. Art is, however, neither one nor the other. After working from a slide for a minute or two, turn on the lights and forget the slide. Complete the composition, but only in terms of the drawing itself, not the subject. What does the *drawing* need? Where is it begging for a line, a dark, a strong texture? What is the over-riding "form-idea" emerging in the work and how can you capitalize on it and strengthen it? In effect, this is a return to the intellect.

But what do you do if nothing seems to be happening in the drawing? Do something, do anything! Make a new mark or tone arbitrarily; perhaps this will begin to show you the way; perhaps it will be just the right momentum to allow the birth process to begin.

STRUCTURE—OUT OF FOCUS	Put the projector out of focus and show a slide — respond as always to the slide, even though the "subject" is not clearly visible. Respond — empathetically — to the dark and light tonal structure of the form. Use a non-resistant drawing material which will allow you to begin establishing relationships between large areas of dark and light. Work from white to middle gray in the beginning, saving your deepest darks as a "trump card." Bring the image back into focus very gradually and, as the subtleties and the refinements in the image become clear, respond

Colored chalk. Working from a projected image of an old brick wall covered with old posters and children's markings, these two students arrived at very different personal statements. The slide, incidentally, was projected upside down. If you study these two drawings carefully, you'll see which sections of the wall both students reacted to. They simply "used" the wall as a point of departure for intensely personal expressions. Colored chalk. Drawings by Jill Rader (left) and Jose Kozlakowski (right). Photos, Waggaman.

to them in your drawing. Remember, your sense of identification should be with the drawing itself to a much greater degree than with the image or motif.

My classes are always amused when, after doing this exercise, they discover they've been drawing a portrait of an old woman—but, they have done it upside down!

Suggested Materials: 18 x 24 bond paper; black, white, or gray chalk; slides; projector.
Time: One hour.

MORE VARIATIONS

Try the exercise above with a resistant material, such as a pencil or pen and ink. With these materials, you establish your tones by accumulating lines such as you create when you scribble. The more you scribble in any one area, the darker the area becomes.

Create a well structured composition with several lines and tones, and then project an image, chosen at random, on the screen. Relate the image to the composition and modify the composition until it relates to the image or motif. The final drawing should resemble neither the slide nor the original tones, so much as it reflects yourself.

If you have access to slides of old or modern master paintings, these can be

used in addition to your own Kodachrome slides. Of course, these master slides are already profound aesthetic statements, compositions worthy of study. If you use them the same way you've just used your own slides, they should simply suggest a motif from which you can develop a personal statement. Just as the old masters learned a great deal from each other, so can you learn from them in this exercise.

Suggested Materials: 18 x 24 bond paper; variety of pencils; graphite sticks.
Time: Several hours; repeat often.

PROJECTED IMAGES, LIVE MODEL, AND SOUND

An exciting variation on this exercise is projecting an image onto a live model. This is an incredible visual experience. Since the picture projects onto the model's flesh, the model is not only *within* an environment but an integral *part* of it. Music, playing while the model *moves* within the projection area, lends still another dimension to this experience. A slide of a figure, projected onto a moving model, completely blurs one's sense of what is "real." No other exercise described in this book has created as much student interest and has resulted in drawings of such expressive quality.

Suggested Materials: 18 x 24 paper; whatever drawing materials seem most appropriate.
Time: Several hours.

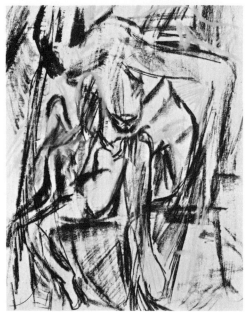

PHYLLIS GOODWIN: *Chalk, tempera paint, ink. Photo, Charles Uht.*
(Above left)

BARBARA HOFFKEN: *Colored chalk. Photo, John F. Waggaman.*
(Above right)

RENE CONRAD: *Chalk washed with water. Photo, John F. Waggaman. (Left)*

These three drawings illustrate several points. The motif—for all three—was a slowly moving model upon whom was projected an image of another model. Note how each student has developed a personal approach to drawing; you would never confuse the work of these three students despite the fact that they had been working in a tightly structured classroom situation for about ten weeks. Note the relationship in each instance between the motif, the given space of the page, the materials employed, and the final form of the drawing.

PETER PAONE
Page of Studies
Pen and ink
Philadelphia Museum of Art
Photograph by A. J. Wyatt.

Artists are perpetually involved in a search; a search for form, a search for truth as they see and feel it. Perhaps this explains why their hands are seldom without a drawing implement. They are probing, seeking after forms, images which will communicate — communicate their very existence and the existence of all men. This page of studies represents such a tentative search by a young American artist. Although this isn't a "finished" drawing, there is a beautiful spatial relationship between the various segments. Even in a page of studies Paone has an intuitive sense of rightness about the organization of the total page. Each form is placed with sensitivity to the previous form. Another painter would simply say that the page "works."

STUART DAVIS
Windshield Mirror
15-5/8" x 25"
Philadelphia Museum of Art
Photograph by A. J. Wyatt.

An American abstractionist, Stuart Davis was in love with the clang, clatter, and excitement of city life. This drawing is a semi-abstract interpretation of the city viewed in the windshield mirror of an automobile. The sharp dark and light pattern and the heavy, unvarying line contrasted with the almost delicate, fussy texture evokes the *quality* of city life. This quality is the drawing's content, and its subject is the city. Other artists have used the city as their subject but the form, or all the elements which comprise the work and content is always unique to each individual artist. Compare this drawing with the city-scapes of John Marin to better understand the difference between form, content, and subject matter.

10 *search for form*

There is no question that you could draw continuously for the rest of your life without ever repeating yourself. Naturally, this is true only if your imagination is extremely flexible, capable of seeing the limitless forms and expressive possibilities inherent in any given subject, event, or experience. Practically all the mature work of the American artist, Stuart Davis, was an expression of city life, yet he never repeated himself. Giorgio Morandi, an Italian painter, spent several decades painting a few bottles. Although his style is always consistent, each painting and drawing is different. Imagine the hundreds of possibilities Edgar Degas found in his principle motif, ballet dancers.

This is not to say that you should choose a theme and use it as a motif for the rest of your life. Not at all. I'm saying simply that within a given motif the possibilities are limitless and that you don't need to search for a new model, a new gesture, a new landscape, or a new theme for each successive drawing you do. You should be able to explore and exploit a motif in depth to discover all its possibilities. Of course, you'll continue to respond to the world around you and to search for new objects and experiences.

VARIATIONS ON A THEME The student drawings reproduced in this chapter illustrate a few possibilities of varying form and expression with a single theme.

Sometimes I ask my students to select a striking photograph from a magazine, a photograph which they liked or disliked intensely when they first saw it. This photograph will serve as the motif for their drawings.

In the two series illustrated in this chapter, both students started by making their first drawing quite realistic, an approach which is not necessary but does help to better understand your motif. After finishing the first drawing, both the original motif and the new drawing serve as the motif for the second drawing; the third variation grows out of the previous two drawings and the original motif, and so on. Though it was not specified as a part of the problem, the students

both simplified the form. The forms became severe, though highly expressive abstractions of the original.

Both of these students have obviously been influenced by Matisse and their final drawings reflect this fact. It's interesting how Dennis, who has been producing literally hundreds of these highly simplified, Matisse-like drawings, moved from the original motif of relative realism right back to the expressive mode with which he was currently pre-occupied. However, the form which he finally arrived at, despite its relative abstraction, absolutely depends upon the original motif and the drawings preceding it.

 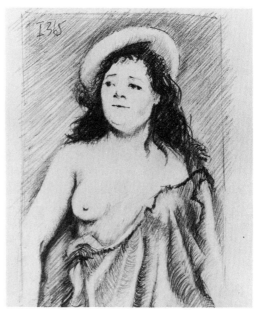

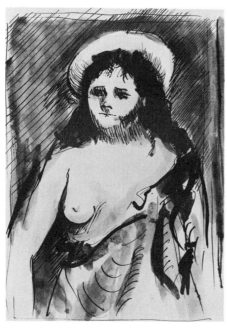 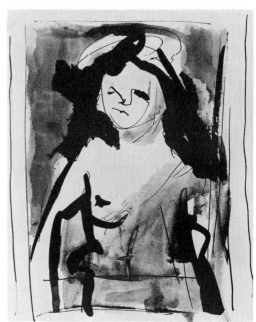

Variations on a theme by Dennis Wunderlin.

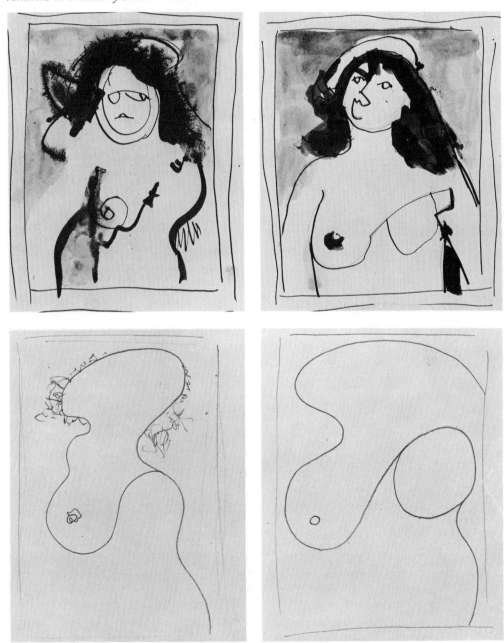

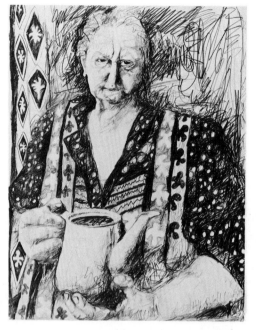

The original motif for this series, a photograph, has been lost. Here are just three of the twelve variations. Drawings by Marilyn Motz.

VARIATIONS ON OLD AND MODERN MASTERS

Often, instead of using a photograph as the motif for variations, I ask the students to select a drawing or a painting by an old or modern master. At times, I may impose a further limitation by asking them to use only the linear characteristics of the old master work as the motif; or to use only the tonal qualities of the old master or perhaps only the textural qualities. The exercise is not designed for them to copy the old master but to study its structure, endeavoring to arrive at a personal and original form statement.

VARIATIONS ON LETTER FORMS

I give my students an exercise which gives them perfect leeway to draw as they please, with one limitation: they must use letter forms as their point of departure. This illustrates the variation in form and expression which students can bring to a given problem.

THE RANGE OF POSSIBILITIES

Notice the still life series on page 138, consisting of four drawings by four different students. Note the incredible differences in their interpretations, each different in concept and yet valid for the particular student.

(Left) Drawing using letter forms in collage and ink by Barbara Kramer.

(Below Left) Drawing using letter forms in pencil by Mary Vrabec.

(Below Right) Drawing using letter forms in pencil and marking pen by Janet Freeman.

In this instance, I set up a relatively simple still life, dominated by a bouquet of live flowers, and I asked the class to use the motif in any way they chose. After only twelve weeks of classes, these drawings illustrate that the students are ready to "attack" all subjects, confident of being able to produce something significant. It's interesting to note how the form of each drawing has been conditioned by the student's choice of material.

Marianne Glick

Kathleen Gorman

Riki Tananbaum

Rene Conrad

glossary

Academic Art or art training which conforms to set rules or traditions.

Aesthetic Expression (meaningful content) given tangible and *organized* form. Ambiguous term referring to whatever is beautiful in art and life.

Artist's Means Materials (stone, paint) and elements (line, textures) which lie between the artist's expressive intentions and his realized product.

Automatic Drawing A drawing which has no motif outside itself and which has been realized through a series of unconscious, intuitive, and automatic responses first to the page itself and then to each successive line or tone.

Bistre A brownish pigment made from wood soot.

Calligraphy Beautiful handwriting and the art of producing it.

Cartoon A preliminary drawing in which compositional problems are resolved before beginning to work on the final painting or mural. Also refers to humorous drawing employing gross exaggeration.

Chiaroscuro "A manner of creating figures from a deeply shadowed background into atmospheric light....usually associated with those studies which have similar relationships of dark tonal backgrounds and figures largely defined by prominent, applied lights." (Watrous, J., *The Craft of Old Master Drawings*, p. 34)

Closure A phenomenon making it possible to "read" a given form in its totality, even though only a portion of it is actually indicated.

Collage A work of art created by pasting paper, cloth, or other objects together to form an image. Generally two dimensional in nature, but often becomes quite three dimensional. May be combined with drawing and painting.

Composition Problem of relating all the elements of a drawing to one another and to the format. Often used synonymously with organization, structure, and design.

Content Often confused with subject or motif; it is, in fact, the expressive nature of the artist's means and their relationships. An abstract drawing may have content, though it has no tangible subject matter.

Contour Drawing A method of drawing in which forms are given meaning through the use of a descriptive line. In effect, this line becomes a symbol for the form, indicating not only the two dimensional shape of the form, but also its existence in three dimensional form on a flat surface, the picture plane.

Design See Composition.

Direction The movement, circuit, or path which leads the eye. This movement is established by the relationships existing between elements inherent in a particular form.

Distorted Form A form which is inconsistent with actuality, created either for expressive purposes or as a result of inadequate skill.

Drawing The process of delineating (with line and/or tone) expressive forms — either abstract or realistic — and the relationships existing between the forms; delineating with some type of marking implement such as a pencil, pen, brush, or finger paint.

Elements The building-blocks of art, comparable to the ABC's of language. There is some disagreement over terms, but in this book, line, shape, color, texture, and space are considered the elements of art.

Empathy The ability of a person to identify with the feeling-state of another person or to project himself into the existence of an inanimate object.

Equivocation A means of relating figure and ground or positive and negative space within a given work. An ambiguous dimension or element which may be "read" in more than one way; a kind of optical illusion. This phenomenon is sometimes called figure-ground interchange.

Expression Refers to the artist's personal statement; that which he is trying to communicate in unusual terms. Expression may range from being relatively objective to passionately subjective.

Figure The drawing or positive image as opposed to that which remains (the ground or field). Figure also refers to the human body.

Form A rather ambiguous term with dual meaning. Most often, the term refers to the totality of a particular work. However, we often speak of a *specific* form within a total composition.

Format The shape of the surface on which the artist works: horizontal, vertical, long, large, small, short, etc.

Gesture Drawing A drawing which grasps the essential movement, disposition, or masses of a motif almost instantaneously. This is usually accomplished by using a "scribbly" line or tone which is a visual counterpart of the artist's total identification with the motif.

Gouache An opaque watercolor made by mixing white with transparent watercolors.

Ground The field, space, or paper on which a figure or positive space is created. Also referred to as negative space.

"Holds Together" A term used when the work functions as an entity, all parts being in relationship to the whole.

Hue The name of a color, such as blue or blue-green. There are both warm and cool hues, red being the warmest and blue the coolest.

Intensity The brightness or dullness of a color; its tendency toward or away from gray. Sometimes called chroma or saturation.

Intuitive A response, in creating a drawing, which is not the result of reasoning, but rather of instinctive insight or perception.

Kinesthetic The quality in a drawing or in its creation which causes a sensation of movement, position, or strain in the viewer or the artist.

Line An art element which is an abstract invention of man used to delineate the contour of a three dimensional form, the juncture of two planes, the outside limit of a flat plane or color spot.

Literary Values The qualities in a drawing which refer to experiences, events, or objects in the "real" world, the world existing outside of the drawing itself.

Media The materials, such as pencils, pens, inks, paints, stones, etc., used to create a work of art.

Modeled Drawing A method of drawing which delineates form through the use of a variety of values; a range of tones from light to dark.

Motif The subject, event, or experience which serves as a point of departure for a work of art, whether it is an apple, a mountain, war, scribble, or a "feeling" of tone.

Negative Space (Shape) See Positive Space.

Original Forms, expressions, or concepts which are uncommon, unusual, and individual — at least in terms of the person from whom they emanate.

Outline Drawing A line drawing which refers only to the outside edge of a given form. It does not suggest the contour, and is therefore flat, two dimensional; a silhouette.

Pattern Forms, lines, or symbols which exist on the picture plane and therefore describe space as it moves horizontally, vertically, or diagonally *across* the page rather than *into* the page.

Perspective The major means of achieving the illusion of space, developed in western art since the Renaissance. This is a complex system — accomplished either free-hand or mechanically — which involves accurately rendering the phenomenon that makes objects appear to diminish in size as they recede from the spectator.

Picture Plane The flat, two dimensional surface of the paper, canvas, or other material on which forms are delineated.

Plane The flat, curved, or convoluted surface of any form whether it be two or three dimensional.

Plastic A term used to denote the illusion of three dimensionality or movement into the picture plane as it relates to the flat, two dimensional nature of the picture plane itself. We refer to this as *plastic space* in contrast to perspective space. Sometimes used to denote everything that falls within the province of form and color.

Positive Space (Shape) Refers to the intentionally created image. The shape of a drawn circle is a positive shape (figure) whereas the space surrounding it (ground) is the negative shape or space.

Principles of Art Refers to broad, ambiguous concepts through which an artist organizes the various elements at his disposal to create a work which has unity with variety. Balance, harmony, and rhythm are the principles most often referred to, as well as proportion, emphasis, and movement. As means for organizing a work of art, I tend to prefer the terms, proximity, similarity, direction, and equivocation.

Proportion A difficult term which generally refers to the "accurate" relationship of part to part in a realistic drawing. However, the term also refers to expressive purpose; for example, an artist distorts proportions (or uses proportion of value) to consciously or unconsciously achieve his intentions. Proportion also relates to the sense of balance.

Proximity A principle of organization through which forms relate as a result of their location to similar or dissimilar forms. Generally, the closer things are to one another, the greater the tension between them, and therefore their relationship intensifies.

Quick Contours Drawings which — although maintaining the general character of the studied or sustained contour drawing — are produced rapidly, often eliminating all but the essentials of a given motif. The representation of the essence of the motif.

Realism In drawing, this term generally refers to forms delineated in such a way that they give the illusion of being the actual form. In this sense, we speak of photographic reality which is a limited concept of the term.

Representational A drawing which attempts to achieve a near-likeness to the objects being drawn. Drawings which strive to achieve the qualities of photographic realism.

Rhythm Often considered a principle of art. Refers to the movement suggested through the placement or repetition of lines, shapes, textures, colors, or forms.

Scale The size of a drawing in relation to the object being delineated. Scale might be one half or double the actual size of the object.

Sepia A dark brown pigment derived from the secretions of cuttlefish.

Shape The form and/or outline of a real or imaginary object created when one line meets another or created by the perimeter of a given mass. Sometimes used synonomously with form and mass.

Significant Form Term coined by Clive Bell to denote the "one quality without which a work of art cannot exist." The aesthetically moving forms of lines and colors "arranged and combined according to certain unknown and mysterious laws…"

Silverpoint Rarely used today, silverpoint was a favorite medium of the old masters. A piece of silver, ground to a point, is used to draw on paper specially prepared with powdered bone and gum. The resulting line is delicate, pale, and crisp.

Similarity A principle of organization through which forms relate as a result of their likeness to one another.

Sliding Plane A plane which is not clearly delineated on all sides, therefore relating intimately to its adjacent plane and creating the effect of equivocal space.

Space Perhaps the most complex of all elements. Basically, there are two kinds of space in art: 1. space which creates the illusion of three dimensionality or movement into the picture plane. 2. space which operates two dimensionally across the surface of the picture plane.

Structure See Composition.

Style The individual artist's unique method of working, thinking, feeling, and seeing which results in an end product that can be recognized as his own. More broadly applicable to places or periods of time in history, e.g., the style of the Renaissance, the New York School, School of Paris.

Subject Matter The object, experience, or event used as a motif or motivation for creating a drawing.

Symbols Drawings which stand for or recall something else — such as an idea, quality, or condition — by suggestion or association in thought. An object in a drawing, such as the cross as a symbol for Christianity. On the other hand, all drawings may be considered symbols.

Technique Refers to the artist's individual way of using an art material. For example, Goya's technique of creating a wash drawing is very different from the technique of Tiepolo.

Tension The quality of pulling, straining, or stretching between various elements within a composition. Static elements lack this dynamic quality.

Texture The actual or implied tactile surface quality of objects.

Three Dimensional Refers to forms which suggest the dimensions of length, breadth, and depth.

Two Dimensional In drawing, refers to a form having only the characteristic of length and width. Lacks the dimension of breadth.

Unity The quality of oneness and tonality which characterizes all works of art. Unity is created through the integration of all the artist's means in making his statement.

Value A dimension of color referring to the amount of light (tint) or dark (shade) contained in the color. Value is often used synonomously with tone.

Wash Ink or pigment which has been watered-down, producing a transparent quality when brushed over other lines or tones.

"Works" "It works" or "It doesn't work" are vague terms used by artists when they discuss a particular painting or drawing. In more pedantic terms they are saying, "The organization of this drawing creates an expressive form in which all of its parts, as well as the artist's intentions, are related to one another and to the total form in a unique and distinctive way."

bibliography

BEAN, JACOB. *100 European Drawings in The Metropolitan Museum of Art.* New York: The Metropolitan Museum of Art, 1964.

BEAN, JACOB and STAMPFLE, FELICE. *Drawings From New York Collections: The Italian Renaissance.* New York: The Metropolitan Museum of Art and The Pierpont Morgan Library, 1965.

BENESCH, OTTO. *Rembrandt: Selected Drawings.* London, New York: Oxford University Press (Phaidon Press), 1947.

BERENSON, BERNARD. *The Drawings of the Florentine Painters.* Chicago: University of Chicago Press, 1938. Amplified edition. 3v.

BOWIE, THEODORE. *The Drawings of Hokusai.* Bloomington, Indiana: Indiana University Press, 1964.

de TOLNAY, CHARLES. *History and Technique of Old Master Drawings.* New York: H. Bittner and Company, 1943.

HALE, ROBERT BEVERLY. *Drawing Lessons from the Great Masters.* New York: Watson-Guptill Publications, 1964.

HAVERKAMP-BEGEMANN, EGBERT, LAWDER, STANDISH D., and TALBOT, CHARLES. *Drawings from the Clark Art Institute.* New Haven: Yale University Press, 1964. 2v.

HOLME, BRYAN, ed. *Master Drawings.* New York, London: Studio Publications, 1943. 1948.

HERBERT, ROBERT L., *Seurat's Drawings.* New York: Shorewood Publishers, Inc., 1964

MERMOD-LAUSANNE, EDWARD., ed. *French Drawing of the 20th Century.* New York: Vanguard Press, "n.d."

METROPOLITAN MUSEUM OF ART. *European Drawings.* New York: The Metropolitan Museum of Art, 1943. 2v.

MONGAN, AGNES. *One Hundred Master Drawings.* Cambridge: Harvard University Press, 1949.

MONGAN, AGNES and SACHS, PAUL J. *Drawings in the Fogg Museum of Art.* Cambridge: Harvard University Press, 1946. 3v.

MOSKOWITZ, IRA., ed. *Great Drawings of all Time.* New York; Shorewood Publishers, 1962. 4v.

MUSEUM OF MODERN ART, WHEELER, MONROE., ed. *Modern Drawings.* New York: Museum of Modern Art, 1944.

POPHAM, ARTHUR E. *The Drawings of Leonardo da Vinci.* New York: Reynal and Hitchcock, 1945.

REYNOLDS, GRAHAM. *Twentieth Century Drawings.* London: Pleiades Books, 1946.

SACHS, PAUL J. *Modern Prints and Drawings.* New York: Alfred A. Knopf, 1954.

SACHS, PAUL J. *The Pocketbook of Great Drawings.* New York: Washington Square Press, Inc., 1951.

SCHULER, J. E., *Great Drawings of the Masters.* New York: G. P. Putnam & Sons, 1962.

SHOOLMAN, R. L. and SLATKIN, C. E. *Six Centuries of French Master Drawings in America.* New York: Oxford University Press, 1950.

SHOREWOOD PUBLISHERS, INC. *Drawings of the Masters.* Twelve volumes by various authors including the following titles: French Impressionists; Italian Drawings from the 15th to the 19th Century; Flemish and Dutch Drawings from the 15th to the 18th Century; 20th Century Drawings; 1900-1940; 20th Century Drawings: 1940 to Present; German Drawings from the 16th Century to the Expressionists; French Drawings from the 15th Century through Gericault; American Drawings; Spanish Drawings from the 10th to the 19th Century; Persian Drawings from the 14th through the 19th Century, From Cave to Renaissance. New York: Shorewood Publishers, Inc.

TIETZE, HANS. *European Master Drawings in the United States.* New York: Augustin, 1947.

TONEY, ANTHONY., ed. *150 Masterpieces of Drawing.* New York: Dover Publications, Inc., 1963.

VAYER, LAJOS., ed. *Master Drawings: From the Collection of the Budapest Museum of Fine Arts 14th-18th Centuries.* New York: Harry N. Abrams, Inc.

WATROUS, JAMES. *The Craft of Old-Master Drawings.* Madison, Wisconsin: The University of Wisconsin Press, 1957.

index